MUSKOKA II

MUSKOKA II

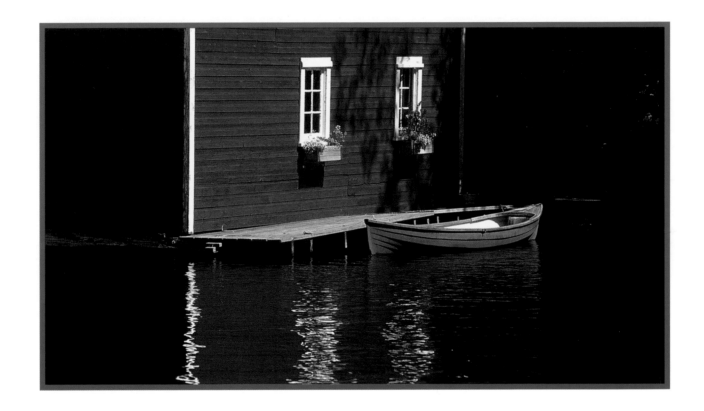

JOHN DE VISSER AND JUDY ROSS

The BOSTON MILLS PRESS

Copyright © 1998 John de Visser and Judy Ross

Published in 1998 by
Boston Mills Press
132 Main Street
Erin, Ontario
N0B 1T0
Tel 519-833-2407
Fax 519-833-2195
www.boston-mills.on.ca

Distributed in Canada by
General Distribution Services Inc.
30 Lesmill Road
Toronto, Canada M3B 2T6
Tel 416-445-3333
Fax 416-445-5967
e-mail gdsinc@genpub.com
TELEBOOK 51150391

Distributed in the United States by
General Distribution Services Inc.
85 River Rock Drive, Suite 202
Buffalo, New York 14207-2170
Toll-free 1-800-805-1083
Fax 1-800-481-6207
e-mail gdsinc@genpub.com
PUBNET 6307949

02 01 00 99 98 1 2 3 4 5

CATALOGING IN PUBLICATION DATA

De Visser, John, 1930–
Muskoka II

ISBN 1-55046-237-7

1. Muskoka (Ont.) — Description and travel. 2. Muskoka (Ont.) — Pictorial works.
3. Muskoka (Ont.) — History. I Ross, Judy, 1942– . II Title.

FC3095.M88D48 1998 971.3'16040222 C98–930320–9
F1059.M9D39 1998

Design by Gillian Stead
Film Reproduction by
Rainbow Digicolor Inc., Toronto
Printed and bound in Hong Kong, China by
Book Art Inc., Toronto

BOSTON MILLS BOOKS are available for bulk purchase for sales promotions, premiums,
fundraising, and seminars. For details contact:

SPECIAL SALES DEPARTMENT, Stoddart Publishing Co. Limited, 34 Lesmill Road,
North York, Ontario, Canada M3B 2T6 Tel 416-445-3333 Fax 416-445-5967

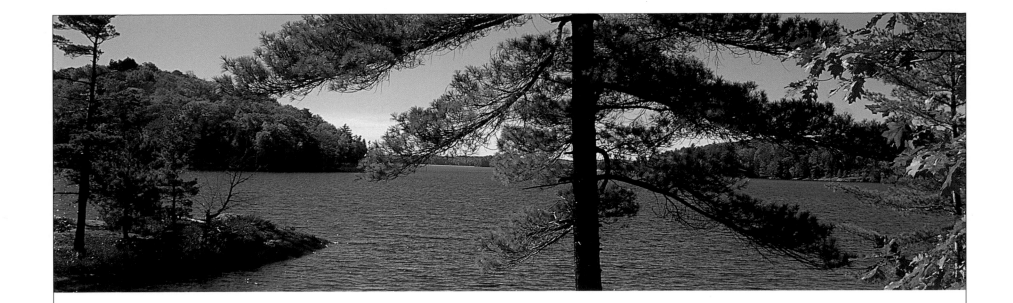

Contents

Muskoka Revisited 7

Sugaring off at Deerhurst *11*

Spring Awakening *15*

Opening up at Wawanaissa *23*

Steamboat Heaven *29*

Windermere Reborn *35*

Cottage Obsessed *43*

The Wanda III *51*

A Day for the Birds *57*

Tiny Islands *63*

Bala Museum *67*

The Dippy Doctor *73*

Dyer's Memorial *79*

Summer's End *85*

Riley's Corn *89*

Cottage Weddings *95*

Cranberry Harvest *103*

Winter Carnival *109*

Winter Weekends *115*

an occasiona
power, he fou
"the country
160 years late
resisted devel
love today —
different from
cottages on th

The desire
dream. We ar
forests with ta
rock. Someho
North, strong
one coast to t
wherever the s

as ever with his camera, I've looked closely at this special place, hoping to find it as lovely, peaceful and unchanged as ever. For the most part it is. The view from my deck is much the same, the air still healthy, the lake still clean, the sunrise over the water still thrilling. And in my particular corner of Muskoka, canoes still outnumber noisy boats. In a fast-changing world, that's almost more than anyone can ask for.

Muskoka Pioneer Village, Huntsville.

Opposite: *Muskoka chairs at Clevelands House, Lake Rosseau.*

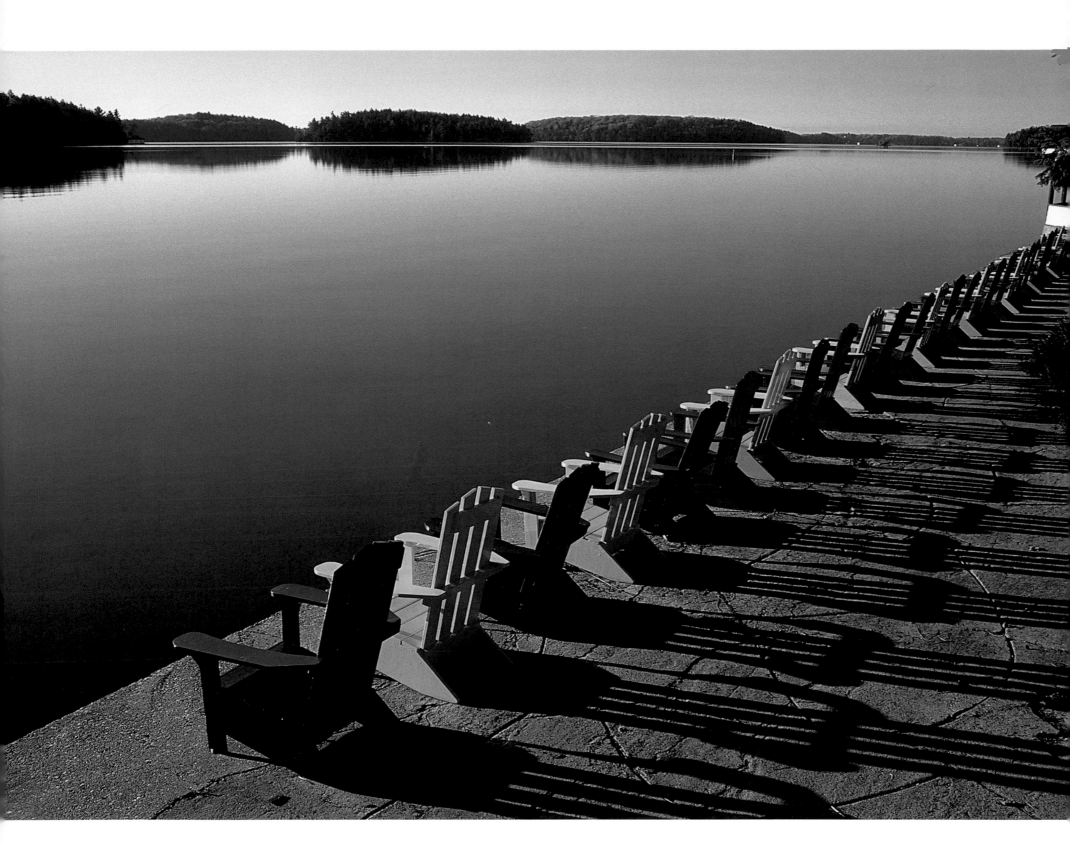

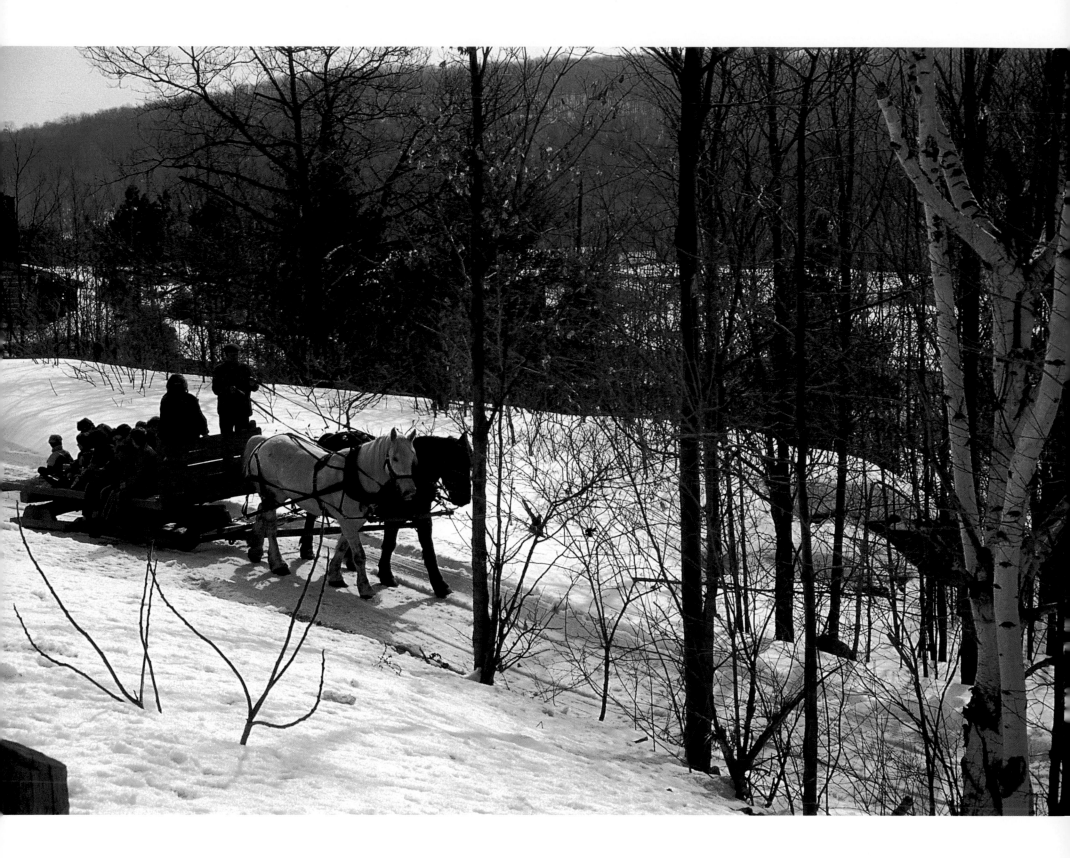

Into the sugar bush at Deerhurst Resort.

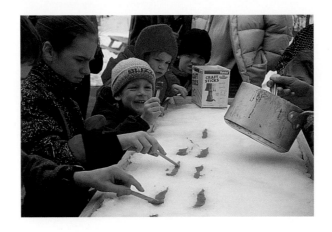

SUGARING OFF AT DEERHURST

The Ontario Northland train from Toronto to Huntsville snakes up the valley of the Don River through suburban neighbourhoods, past horse farms and rolling countryside. It brushes past thick groves of pine and cedar, whistle blowing as it passes by the back doors of lakeside cottages. How good to be leaving the city behind on a damp March afternoon — a fine time to visit Deerhurst Resort, where the maple syrup festival is about to begin.

What started as a hobby for Roger Tremblay, the resort's executive chef, has turned into his favourite annual event. Visitors come from all over the world to partake in this festival. They climb onto a horse-drawn sleigh and tour the sugar bush; they eat salmon poached in maple sap, just one of many French-Canadian dishes that Tremblay creates for the syrup season; and they take home samples of this very sweet, very Canadian treat. "Maple syrup was always part of my life growing up in Quebec," Tremblay explains, "I can still remember my mother making toffee on the fresh snow."

The maple syrup producing operation at Deerhurst began when Tremblay bought five acres of sugar bush on the far side of Peninsula Lake, across from the resort. He started small with about forty taps. After working in the kitchen all day he'd drive over and collect the sap. Some of it was used in the kitchen, some he gave away, but mainly the harvest was for his children — he wanted them to know where syrup comes from.

Today, the Deerhurst maple syrup operation has expanded to about 1,000 taps, with six miles of plastic tubing carrying the clear liquid to the sugar shack, a boiler house with an 88-gallon evaporator. Visitors can purchase bottles of this amber ambrosia at the resort and take home recipes for such treats as hot maple syrup soufflé. But still, Tremblay maintains, "the real purpose is to give our guests the experience of seeing how syrup is made."

On this March afternoon the leaden clouds hang low, threatening more snow. It's not the prettiest time of year in Muskoka, but the weather has been ideal for sugaring off — below freezing at night and warming up to between five and seven degrees Celsius (about 40° F) during the day. If it becomes too hot during the day and buds begin to appear on the trees, the sap will get cloudy. Then it's called buddy sap and it's not as good. The sugaring-off season, as defined by an old adage, "begins when the crows start to caw and the icicles melt and ends when the buds come on the trees."

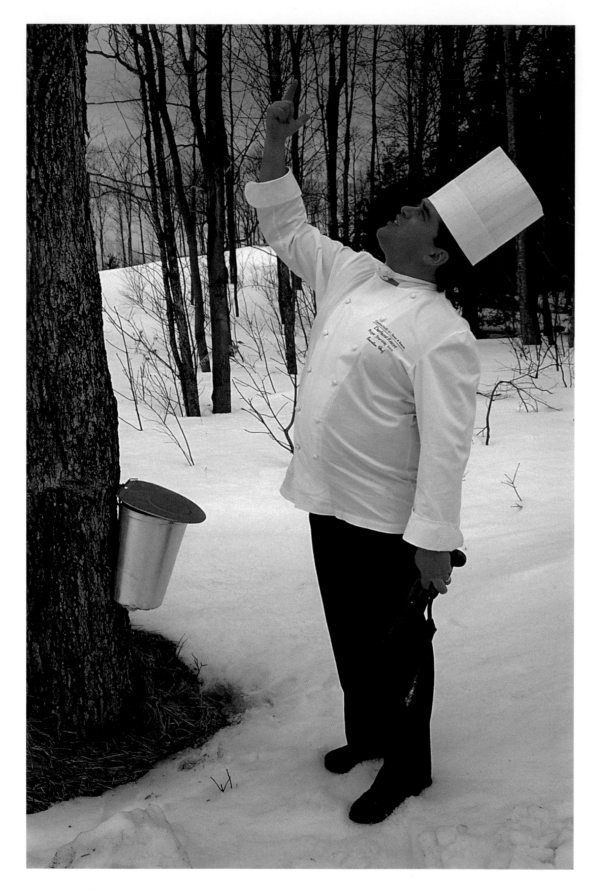

A group of children bundled in snow jackets has gathered around the old red sleigh with its broad wooden runners. Every day during the maple syrup festival the sleigh makes several trips into the bush. Parents hoist their youngsters up to pat Tony and Sandy, the massive Percherons who haul the sleigh up the snowy hill into the woods.

The sap has just begun to run. The children are shown how to tap the south side of the tree using an old-fashioned spigot and bucket. "Oooh," shouts one boy as he licks a drop of sap from his finger, "it's not even sweet!" Then they go into the Sugar Shack to watch the syrup-making process and from there head outside to pour the hot liquid onto the snow to make toffee. They also discover why the sap is not even sweet. It's 97 percent water and it takes more than nine gallons of sap boiled down to produce just one quart of syrup.

Later the children get to feast on pancakes swimming in syrup and nibble on maple fudge candy. And next time they see maple syrup in the grocery store they'll know where it all began.

Deerhurst Executive Chef
Roger Tremblay checking the sap.

Opposite: *A winter sleigh ride.*

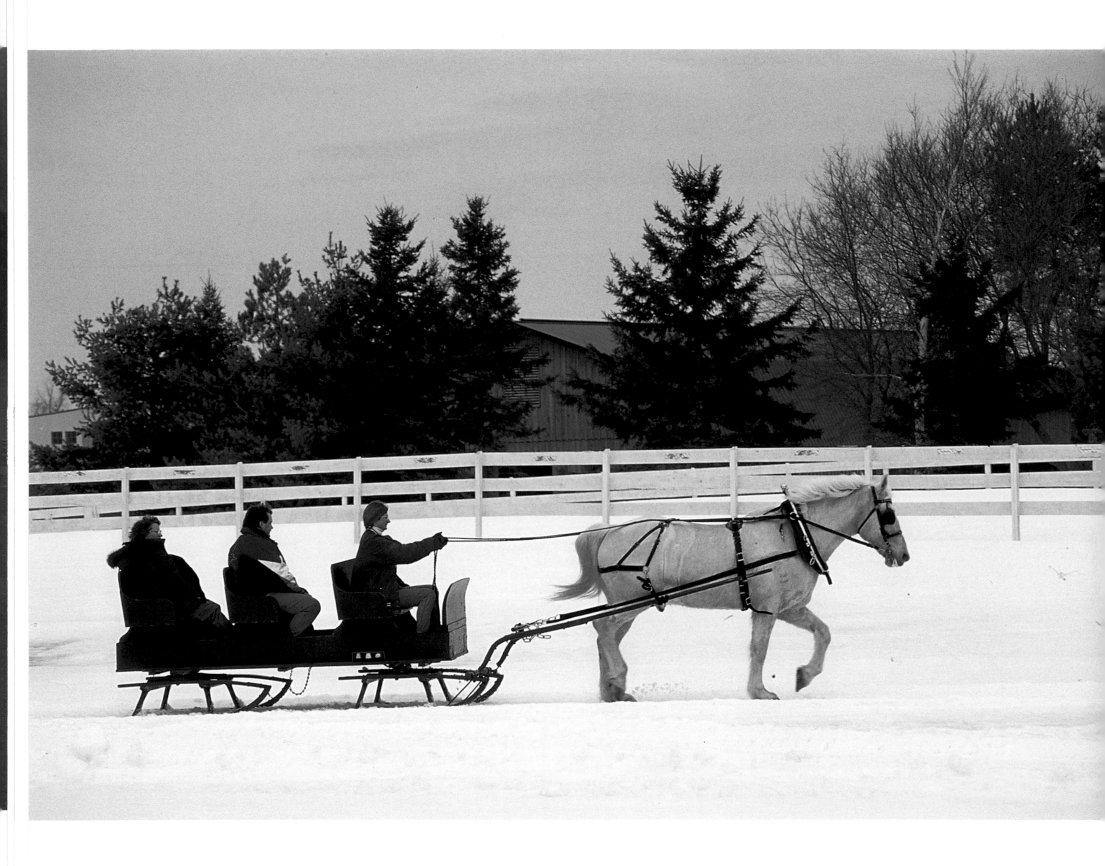

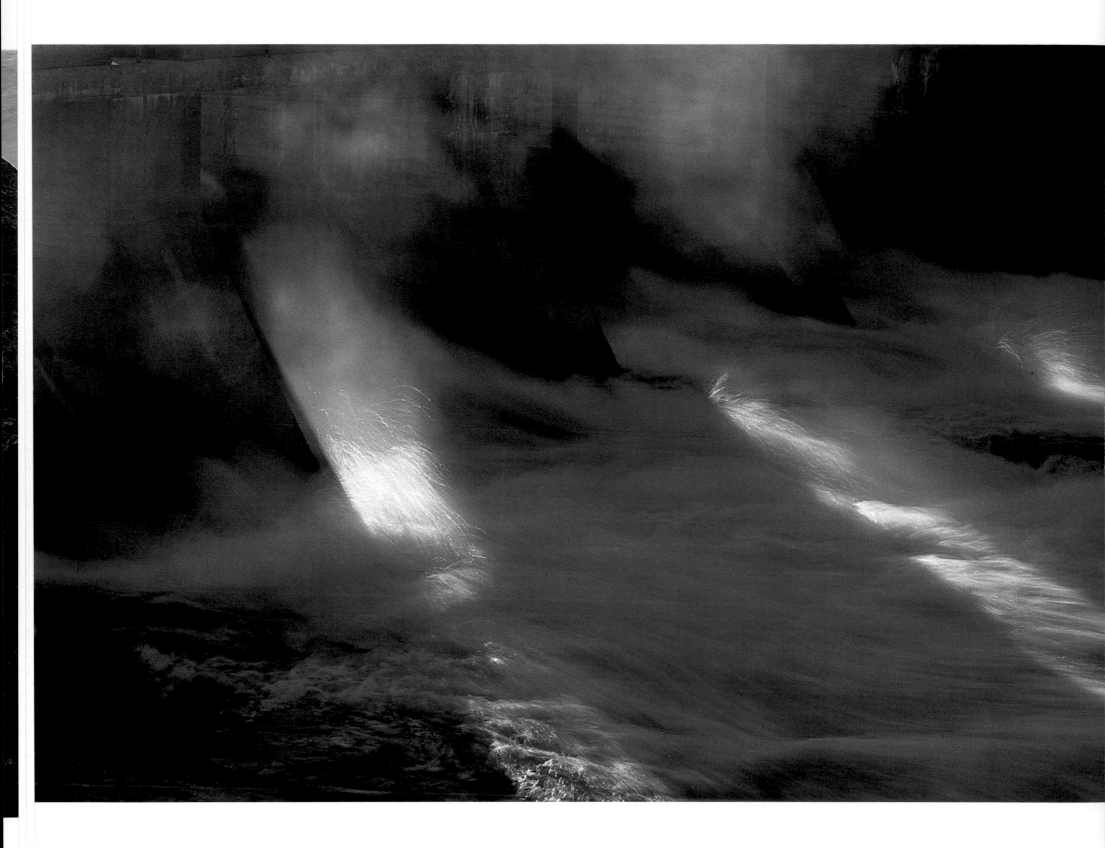

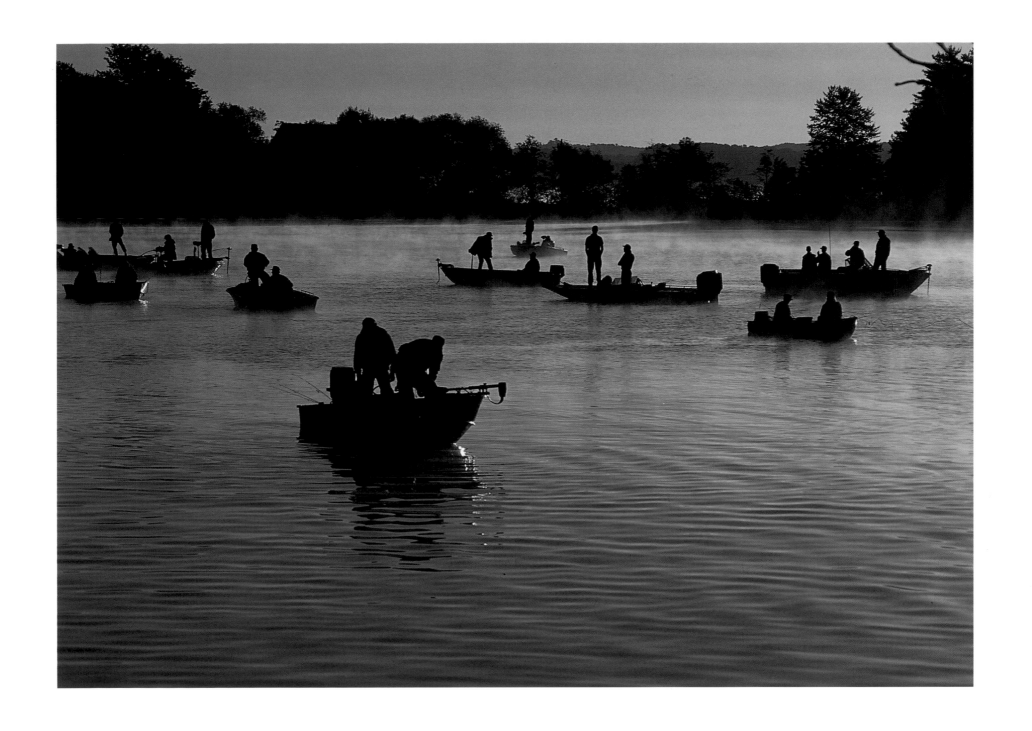

Fairy Lake fishing competition.

OPPOSITE: *Moon River Dam, Bala.*

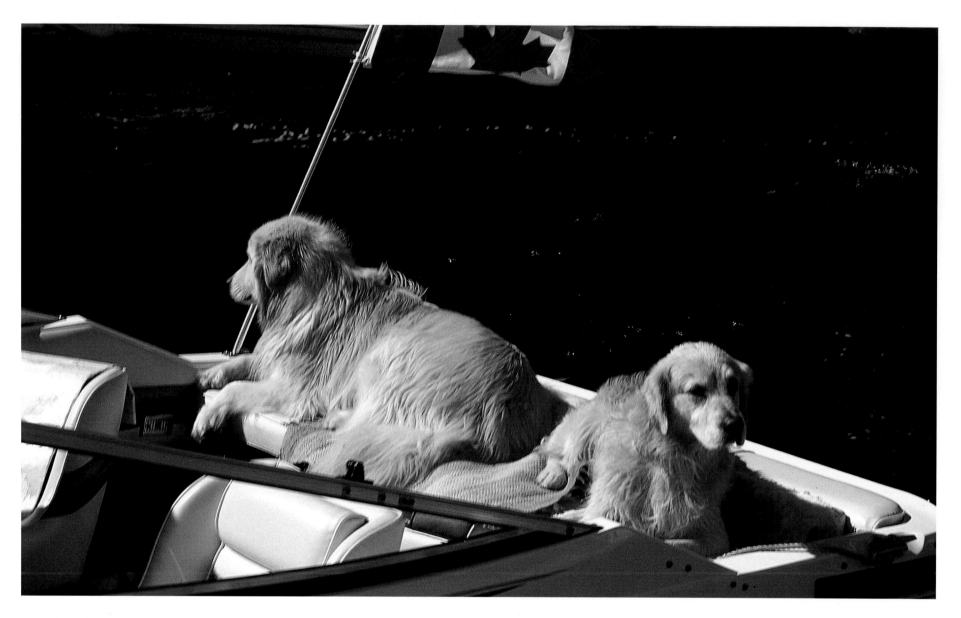

Cruising at Dorset — it's a dog's life.

Opposite: *Along Brackenrig Road, Lake Rosseau.*

fashion, it has been added to and altered to make a cosy summer home for Ernie and his family.

As the day draws to a close, a chill wind blows in off the lake. The cottages are aired, squirrel nests removed from the chimney, most of the dead mice have been swept away, and someone has taken the first dip in the lake, a bone-chilling annual ritual usually undertaken by a brave youngster to inaugurate summer.

Down in the boathouse the last boat has been lowered into the water. The group of men, including Harold Wilson's sons, sons-in-law and grandsons, pauses for a moment to remember him. His presence will always be felt among his fleet of boats in this wooden boathouse on the island called Wawanaissa.

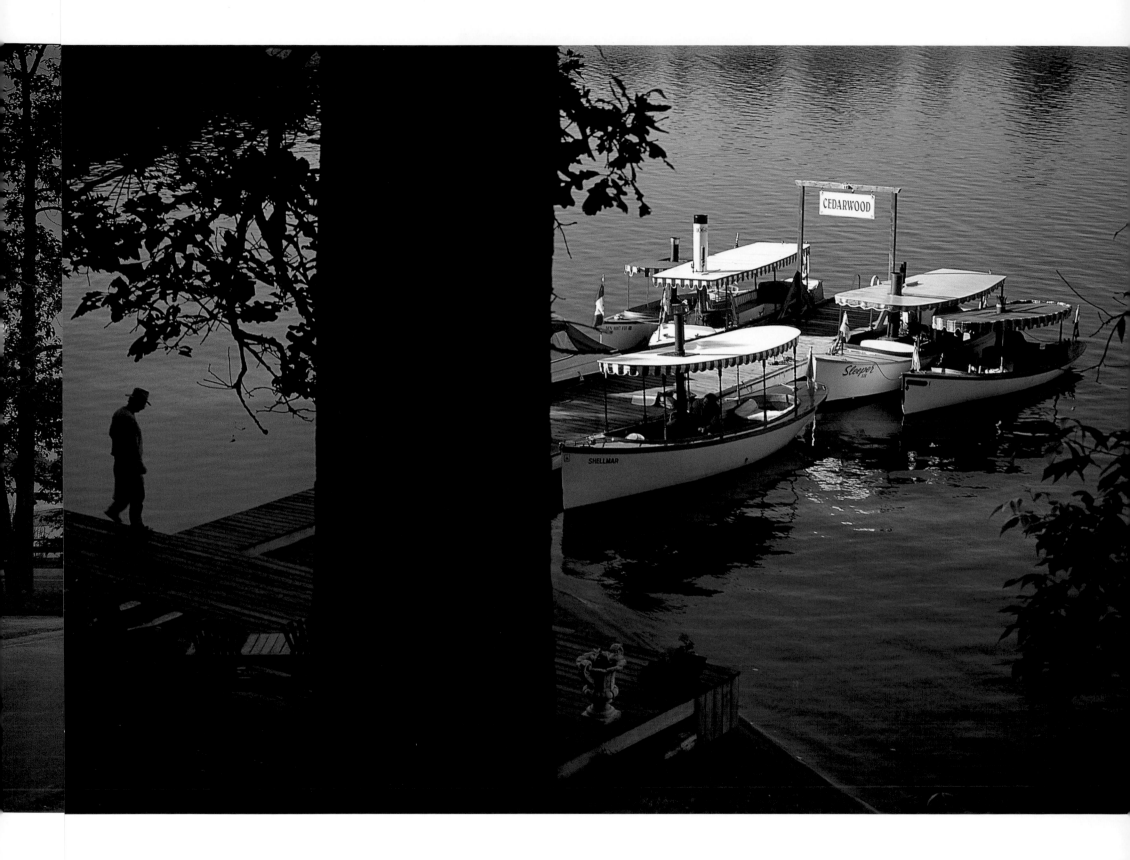

A summer morning on County Road 18.

OPPOSITE: *Steamboats at Cedarwood Resort, Lake Muskoka.*

Enjoying shirtsleeve weather outside Bethune House, Gravenhurst.

Opposite: *Antique and Classic Boat Show, Sagamo Park, Gravenhurst.*

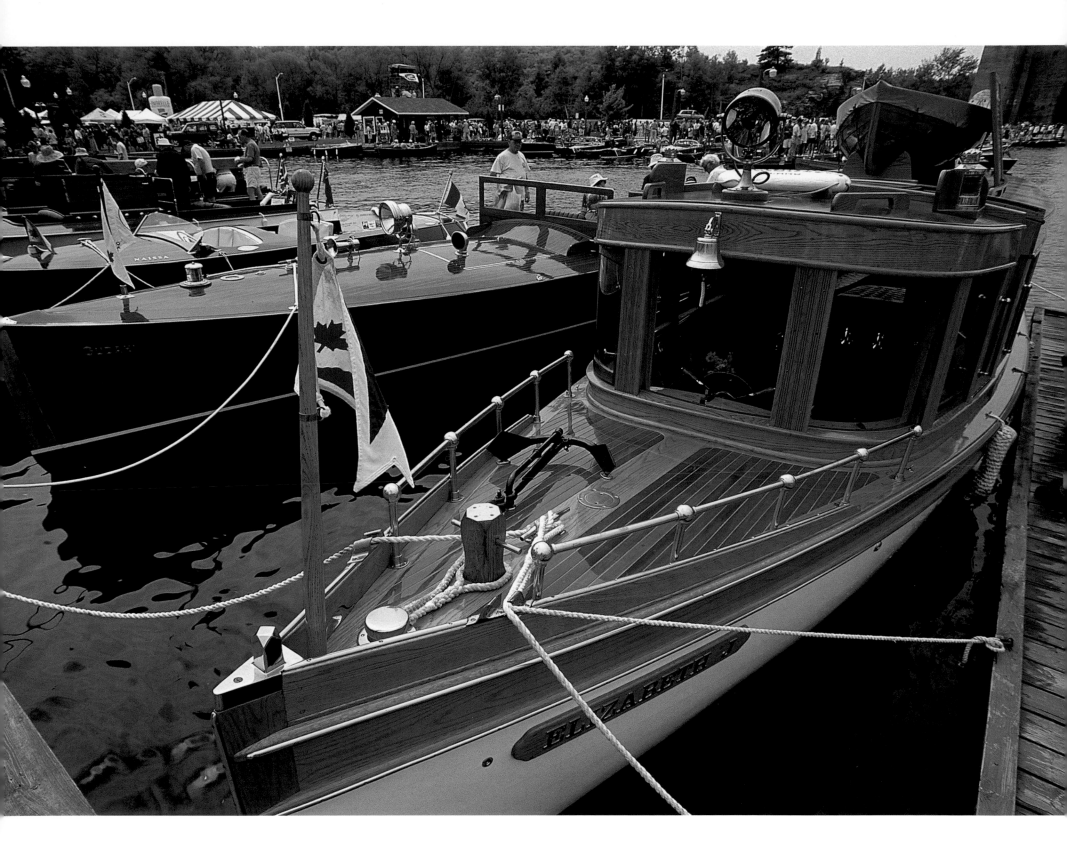

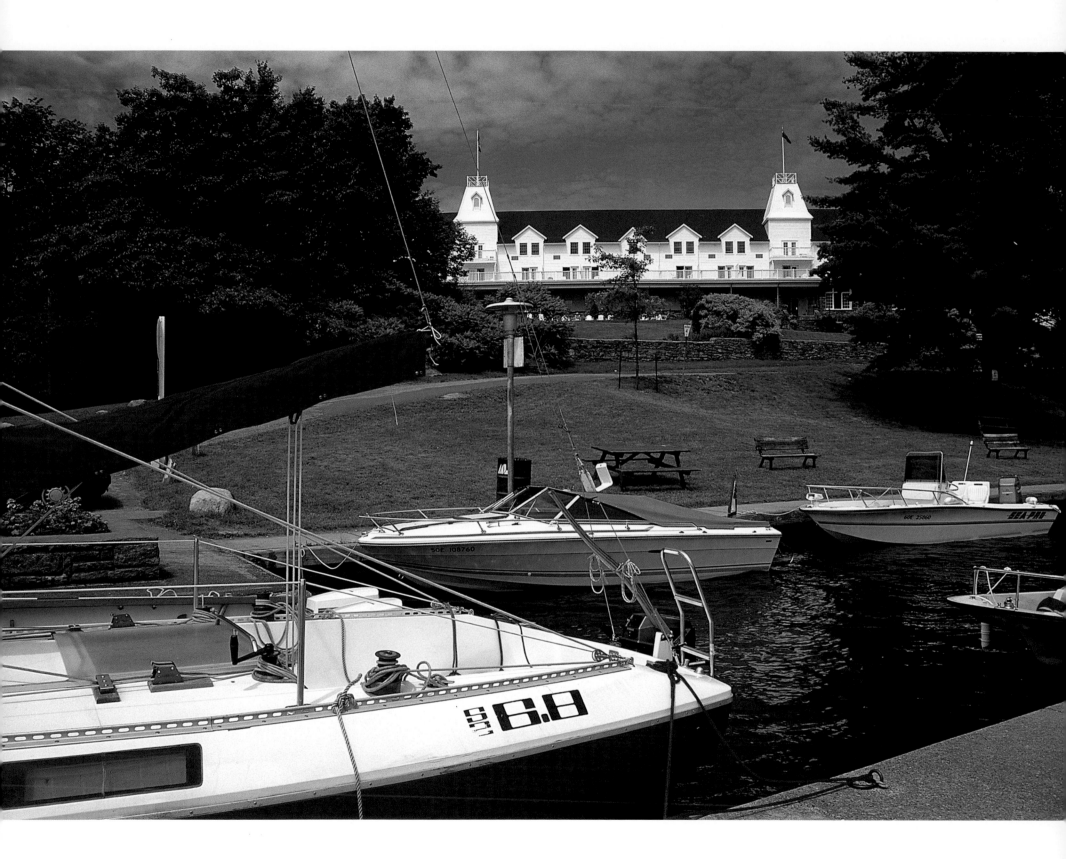

The "new" Windermere House, Lake Rosseau.

WINDERMERE REBORN

It was a cold, still night in Muskoka. February 27, 1996. The normally dozy village of Windermere was swarming with trucks, equipment vans and a film crew of two hundred. A thriller starring Geena Davis was being filmed in the historic Windermere House hotel, the mainstay of the village and a landmark on Lake Rosseau for 126 years. At about eleven o'clock a fire broke out, sparked by a high-intensity light used in filming on the hotel's second floor. Everyone escaped injury, but the beloved three-storey wooden hotel went up like a torch. It burned all night. By morning all that remained were the stone pillars of the front verandah.

This could have been the end of the story — the final chapter in a long saga of Muskoka hotel fires. Instead this is a story of rebirth. In June 1997, thousands of work hours later, Windermere opened again for business. It had been rebuilt — a replica of the original old hotel — within the footprint of the stone pillars.

All summer the curious flocked to the "new" Windermere. Many came by water to gaze upon the view so familiar to anyone who has boated on Muskoka's lakes. There she stood — the grand white building, the cherry red roof, seven dormers across the front and flags flapping atop matching twin towers. One couple arriving by boat looked up and exclaimed in almost reverential tones, "Doesn't *she* look great!"

For everyone who has grown up in Muskoka, either as a cottager or permanent resident, Windermere House is a "she." Affectionately known as the Lady of the Lake, she's an enduring symbol of the golden era when gracious hotels lined the lakeshore. Back then, family groups came seeking the healthy, pine-scented air of Muskoka, and lake steamers ferried them from the train station at Gravenhurst to their favourite summer resort. Some, such as Windermere House, were grander than others, and their guests brought servants and trunk-loads of fancy clothes.

Like many resort hotels in Muskoka, Windermere began as a private home. Settlers who were given land grants in the 1860s and '70s discovered that farming in the rocky Canadian Shield was back-breaking work, so they tossed away their hoes in favour of letting rooms to summer visitors. Scottish settler Thomas Aitken was one such man who became a successful hotelier. Between 1870 and 1904, he extended and embellished his hilltop homestead, creating from it a sprawling hotel for two hundred guests. He named it Windermere after one of his favourite places, a lake in

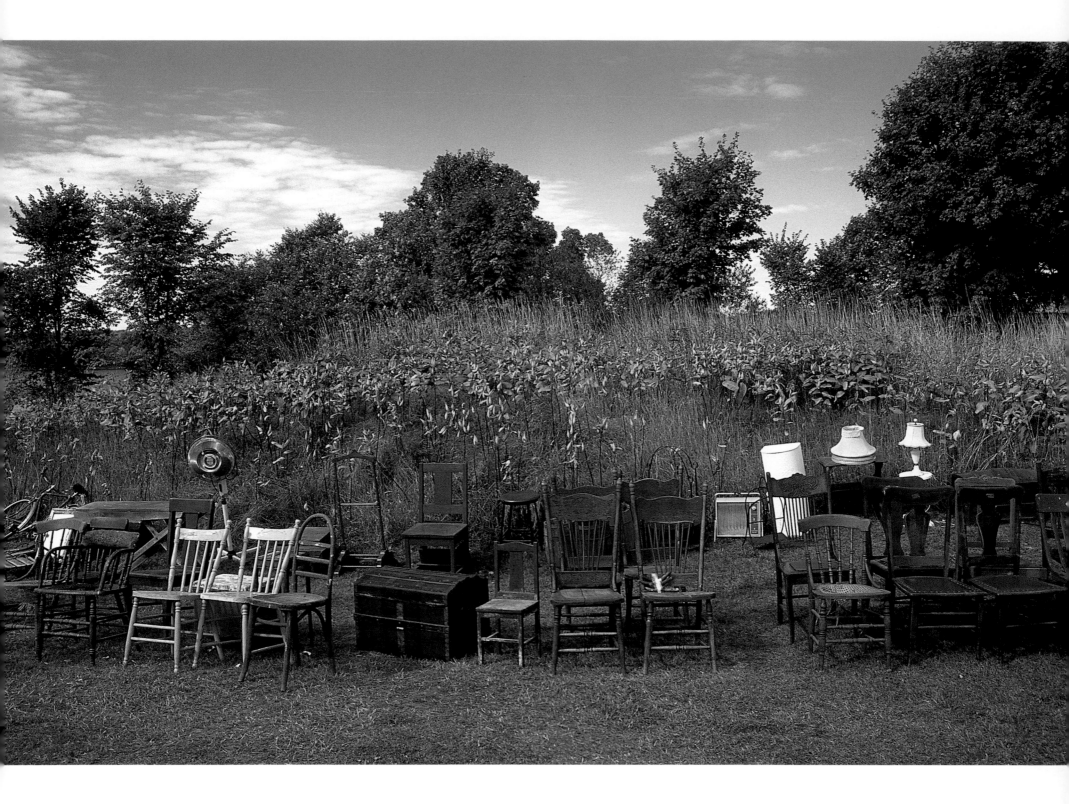

Country auction along Highway 118.

OPPOSITE: *The boathouse at Llanlar, Lake Rosseau.*

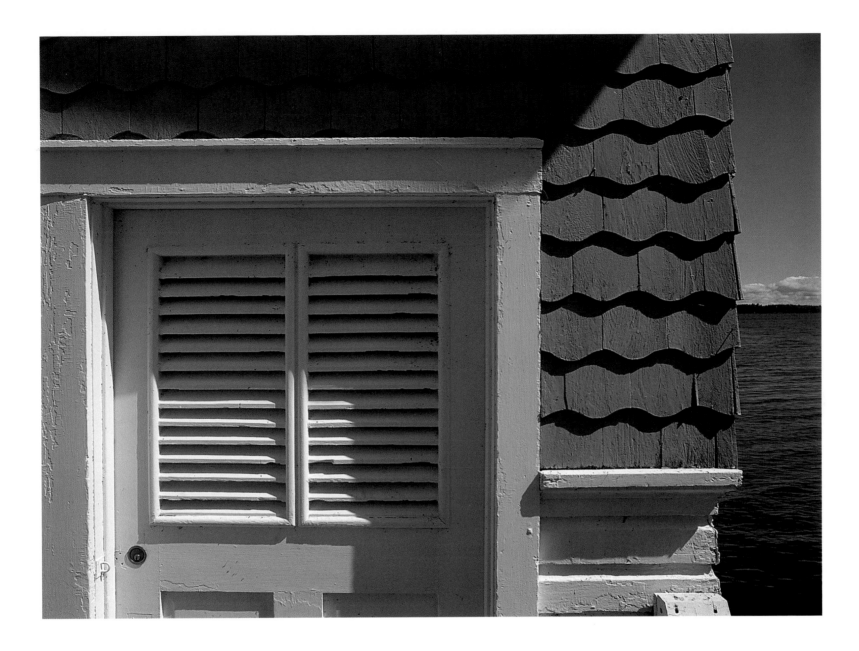

northern England. And it remained in his family until 1981.

In recent years cottagers would take guests to Windermere for a taste of olden days. Sitting on creaky rocking chairs over tea on the verandah, they'd slip into the past talking about ladies in long starched dresses (how uncomfortable!) and men who wore straw boaters at a rakish angle (how dashing!) It all seemed impossibly glamorous. And these days, there isn't much else to remind anyone of that time. That's why, when the hotel burned down on that February night, she took a little of Muskoka's soul with her.

The rebirth of Windermere is a local love story. In the course of just ten months, 72,000 man-hours of work were devoted to getting the Lady of the Lake ready for her 127th summer season. On a warm summer day soon after the hotel reopened, a couple sat sipping cold drinks on the stone patio, gazing up at the gleaming new building. It appeared to have always been there. From their vantage point the only sign of the fire was a burn mark on the old maple tree. Somehow the tree survived and still arches overhead spreading shade on the outdoor patio.

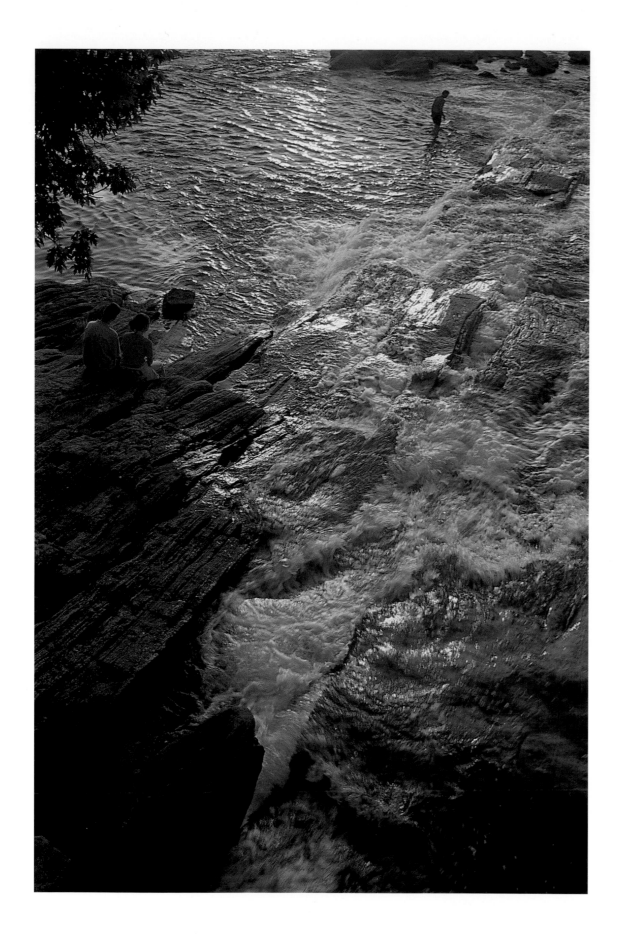

Bala Falls.

OPPOSITE: *Canada Day fireworks, Bracebridge.*

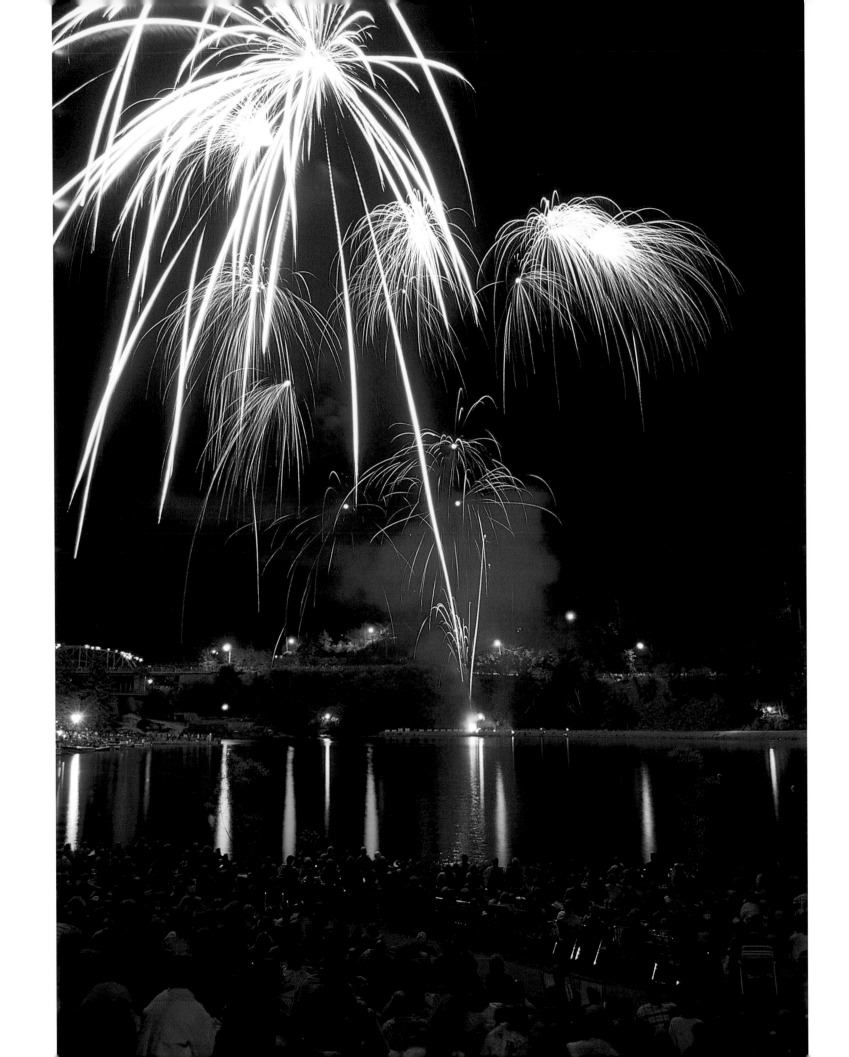

Stone, wood and wicker — cottage basics.

OPPOSITE: *Late afternoon at Aynhoe Point on Gibraltar Island, Lake Muskoka.*

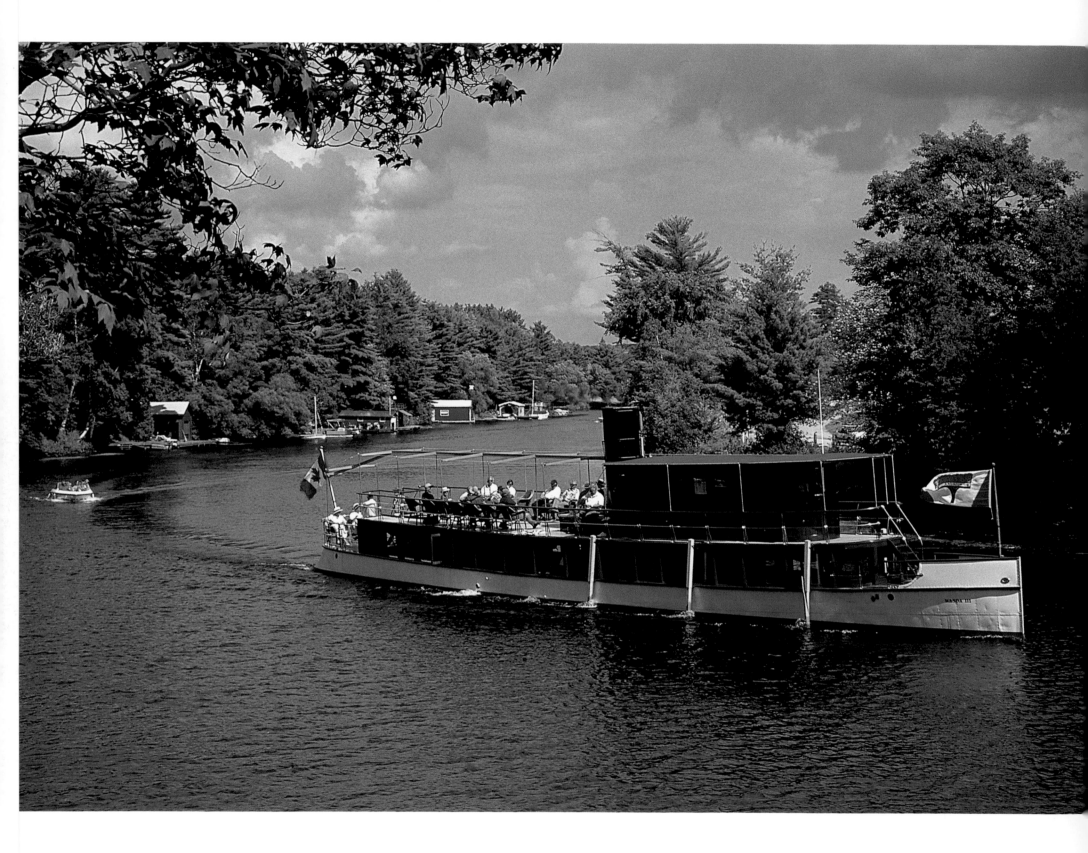

The Wanda III *on the Muskoka River.*

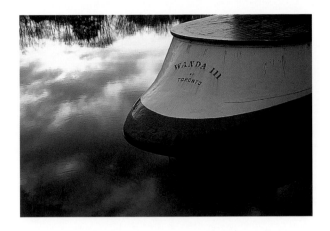

THE WANDA III

It's a Saturday in July, the day of the 18th Annual Antique and Classic Boat Show, and Gravenhurst is snarled with traffic. Policemen direct pedestrians and cars toward Sagamo Park where hundreds of shining wooden boats are tied to the wharfs in neat rows. For visitors it's an awesome sight, a chance to see some of the finest wooden boats ever built. And this year, for the first time, a chance to board the most opulent privately owned steamboat ever to grace Muskoka lakes — the *Wanda III*, built in 1915 for the family of department store magnate Timothy Eaton.

Her official relaunch took place in 1996 with Prime Minister Chretien on hand for the ceremony. Today she's available for forty-five-minute cruises to anyone with fifteen dollars to spare. Her rescue and restoration has been long and costly but successful. "She looks real fine!" comments one visitor, his distinctive drawl identifying him as a visitor from the American South. "I'm going to buy me some tickets for the boat ride!"

The long skinny *Wanda* looks right at home berthed at the wharf at Sagamo Park, across from Muskoka's grand dame of restored steamboats, the RMS *Segwun*. Both are owned and operated by the Muskoka Lakes Navigation Company. While the *Segwun* can ferry one hundred passengers round the three lakes on daily cruises, the *Wanda*, with a capacity of only twenty people, is reserved for private charters and small corporate functions. With these two boats in harbour, Gravenhurst is indeed "steamboat city."

The story of the *Wanda III* begins back in the early days of cottaging in Muskoka. Timothy Eaton, one of Canada's wealthiest men, bought land in the late 1880s near Windermere on Lake Rosseau and built a compound of cottages called Ravenscrag. The property was a long way from the train landing in Gravenhurst, so Eaton ordered a "fast" boat to transport his family and guests from the train to his cottage. The *Wanda I* served her purpose until 1904 when she lost a race and Eaton, who believed in speed, immediately ordered a faster boat. The *Wanda II* was indeed faster — fast enough (up to 21 miles per hour) to win several races, but in 1914 she was destroyed by a fire in the Ravenscrag boathouse. So in 1915, Timothy Eaton's widow commissioned the Polson Iron Works in Toronto to build the third *Wanda*, the largest, and fastest private steamboat in Muskoka.

The *Wanda III* then served the family well — ferrying guests to and from Gravenhurst, taking groups on picnic outings, speeding about the lakes to social events — until a tragedy occurred.

In 1927 a six-year-old girl staying at the summer home of Lady Eaton (Timothy Eaton's daughter-in-law) developed appendicitis in the middle of the night. The *Wanda III* was called upon to rush the

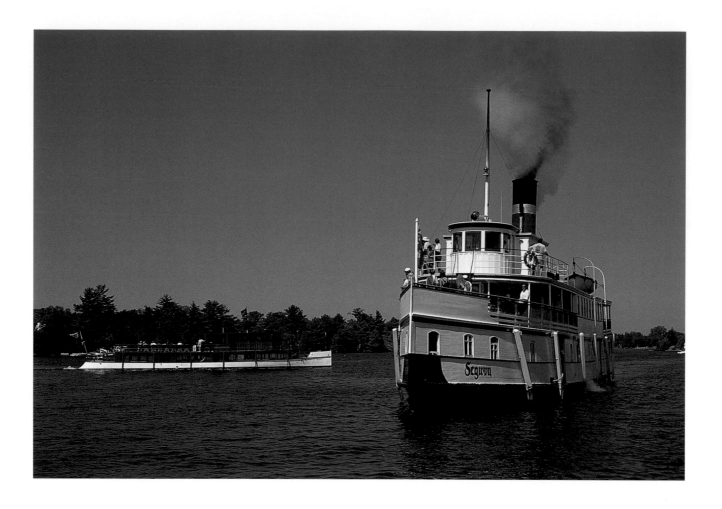

youngster to the South Memorial Hospital in Bracebridge, a distance of several miles. The child died en route to the hospital and Lady Eaton blamed the boat for not being fast enough to save her. She sold it shortly thereafter.

The new owner of the *Wanda III* was C. O. Shaw, the proprietor of the famous Bigwin Inn on Lake of Bays. He bought her to use as the hotel ferry, and transported the 94-foot steam yacht from Lake Rosseau to Huntsville and across the Portage by tractor.

Her life as a ferry nearly met with tragedy as well. One afternoon in the 1930s she was packed with over forty hotel guests enjoying a lake cruise when an airplane suddenly appeared in the sky. This was so unusual in those days that all the passengers rushed to the starboard side to get a better look. With its narrow beam, the *Wanda III* began to roll over and would have capsized if it hadn't been for the

captain's frantic shouts to everyone on deck. Sometime later her passenger certificate was revoked and she spent the following years languishing on Lake of Bays under a succession of owners.

The Muskoka Lakes Navigation Company took over the *Wanda III* in 1993 and mounted a fund-raising campaign with Fredrik Eaton, Timothy Eaton's great grandson, as honorary chairman. Three years later she was relaunched on Lake Muskoka, but with her passenger load limited to twenty-four.

At the Antique and Classic Boat Show the *Wanda III* is a hit. Every fifteen minutes people clamber aboard, filing along the narrow upper deck to the rows of wicker armchairs. Captain Randy Potts welcomes the folks aboard, lemonade is served, and a quick safety routine is demonstrated. Soon she glides away from the dock, gleaming in mahogany, teak and brass, all her bells and whistles ringing.

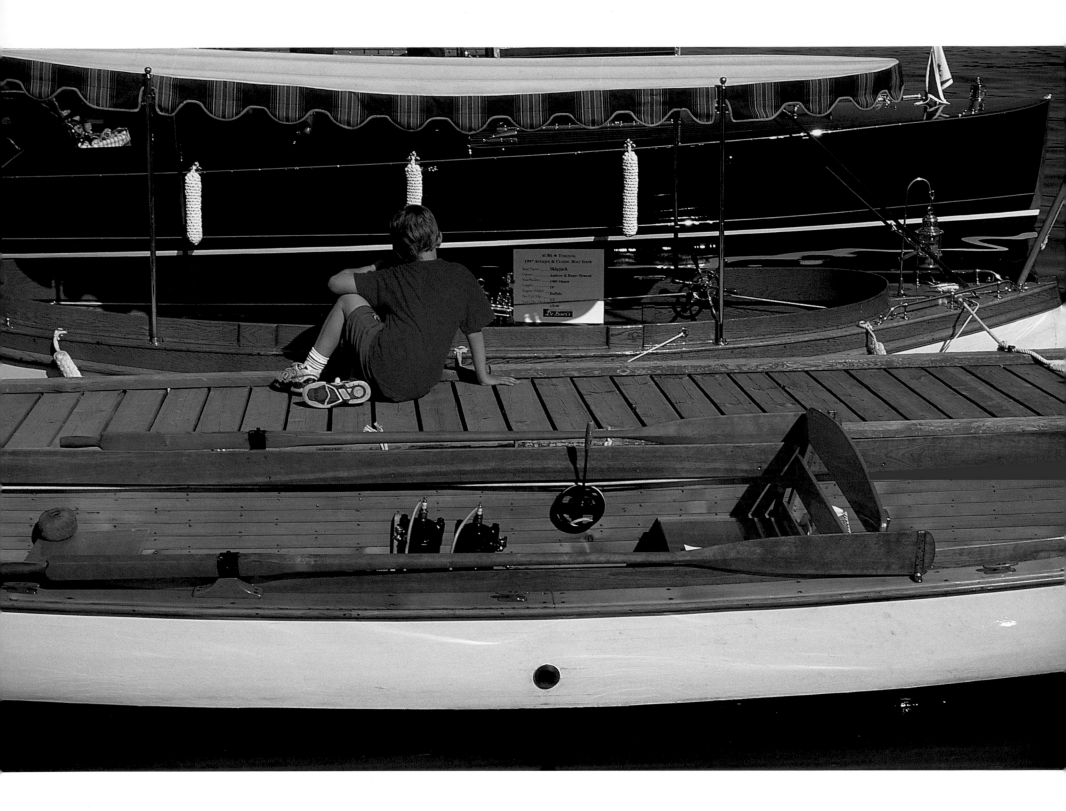

A boy can dream at the boat show.

OPPOSITE: *The* Wanda III *meets RMS* Segwun *in Gravenhurst Bay.*

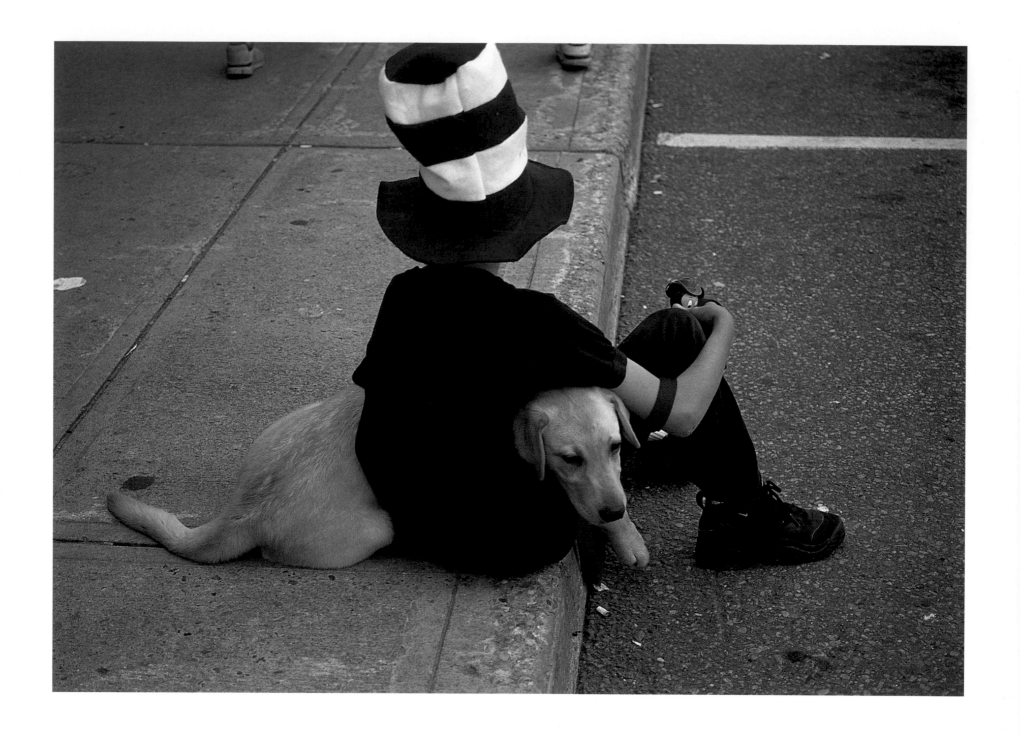

Sidewalk superintendents at the annual Bracebridge Sidewalk Sale.

OPPOSITE: *Christ Church, Port Sydney.*

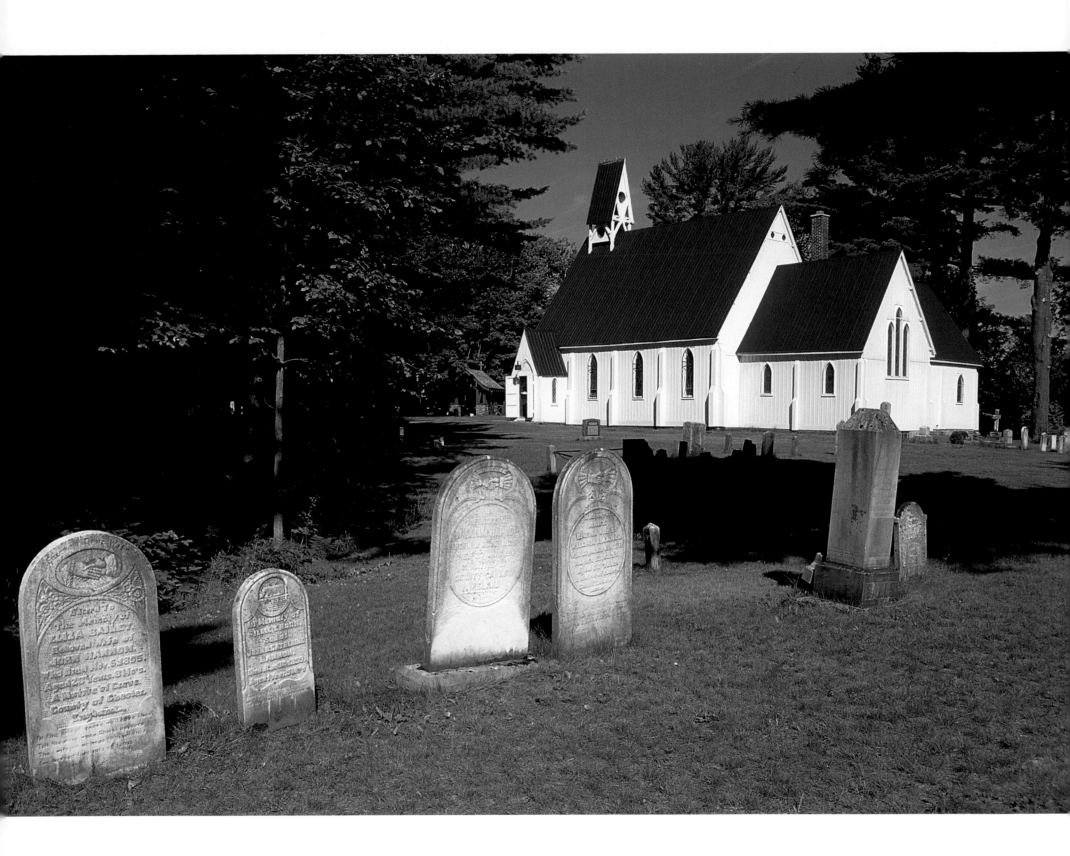

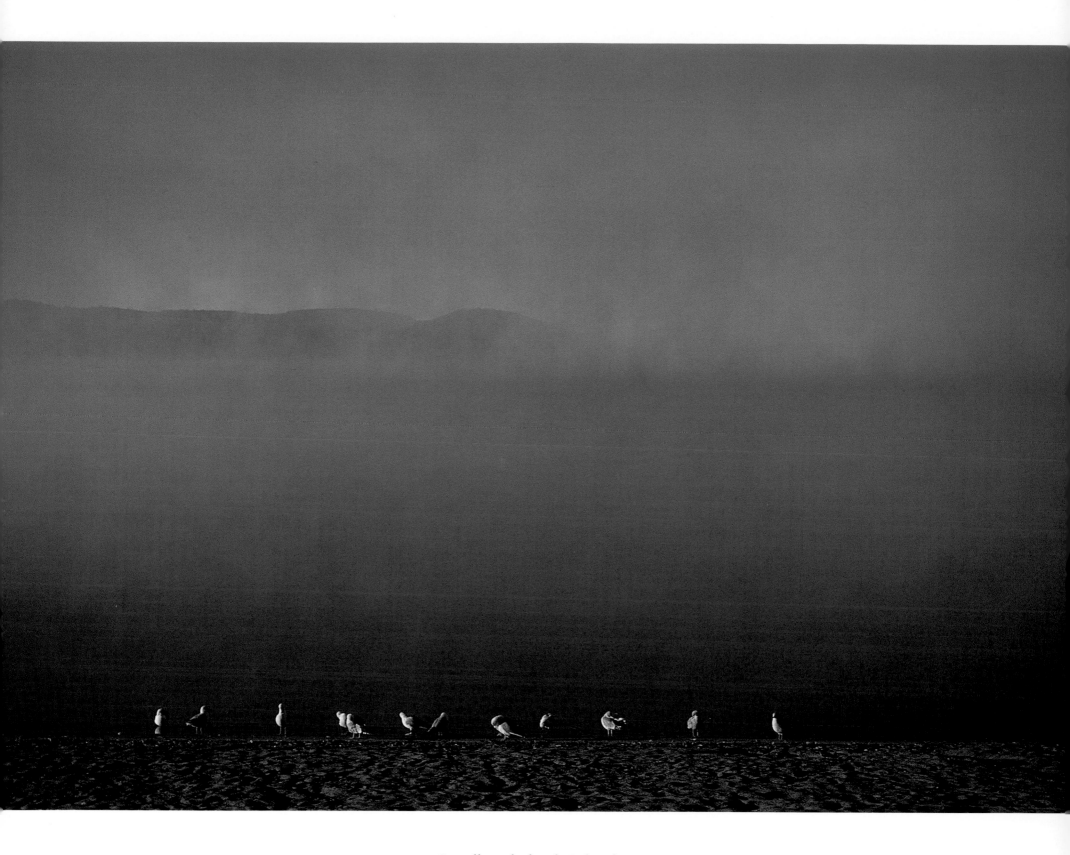

Seagulls at daybreak, Lake of Bays.

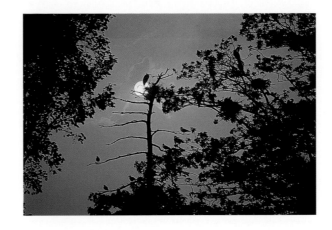

A DAY FOR THE BIRDS

I'm awakened before dawn by the cry of a loon cruising beneath our boathouse window. It's a beautiful morning so I don't mind being wakened. The sky is the colour of a ripe peach, tendrils of mist brush the lake. I get up to watch the loon. There she is, dipping her pointy beak into the water for fish. Her mate calls out from around the bay. Scanning the water with binoculars I try to follow the cries, but he's nowhere to be seen.

It's said that loons mate for life. We like to think that "our" loons are a mated pair but so far we've seen no offspring. Perhaps their eggs have been washed away by boat wakes or those dreaded personal watercraft that careen too close to shore. Or perhaps eaten by raccoons or crows. Loons normally live for thirty years, but still I wonder if my grandchildren will ever waken to their calls beneath the boathouse window.

Later, as I sit reading on the dock and watching the afternoon sun fling diamond sparkles on the lake, I see the blue heron coming in for another of her masterful landings. Skimming the lake surface she drops gently onto the rocky point, her wings as wide as a hang-glider. She steps queenlike, one leg at a time, across the flat rock, and then stops and stands motionless, haughtily ignoring my presence. I put down my book and watch.

When the sun leaves the dock I move to the hammock, slung between two birches, where I can watch the battle at the birdfeeder. In the first round the bluejays scare away the chickadees and finches. But then, leaping from a cedar branch — it's a bird! it's a plane! no — it's superchipmunk. He scrambles over the feeder and hangs upside down, pokes his entire head into the feeder, and fills his chubby cheeks with sunflower seeds. The birds all scatter.

Later, when the lake is covered in a blanket of warm afternoon light, it's time to watch the hummingbirds. Hovering motionless at the deck planter they sip nectar from the bright pink petunias. Like acrobats they dart from blossom to blossom, spiralling up, down and sideways, providing entertainment for the cocktail hour. These teeny creatures, no bigger than my wineglass, are bundles of energy. They flap their wings so rapidly they must refill their bellies about every ten minutes. Come fall, they will fly from our deck all the way to their wintering ground in Mexico. A marathon journey on gossamer wings.

And so ends another full day of bird activity. And some people wonder what we do at the cottage all day long.

Herons nesting.

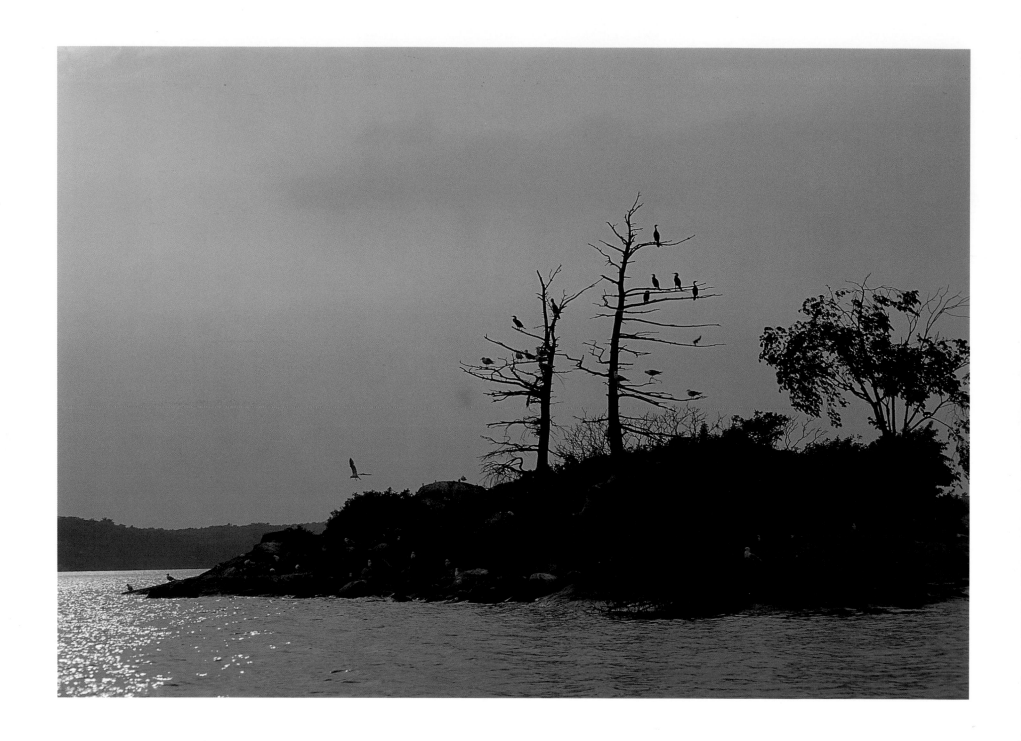

Cormorant trees.

<small>OPPOSITE:</small> *The Black River east of Cooper's Falls.*

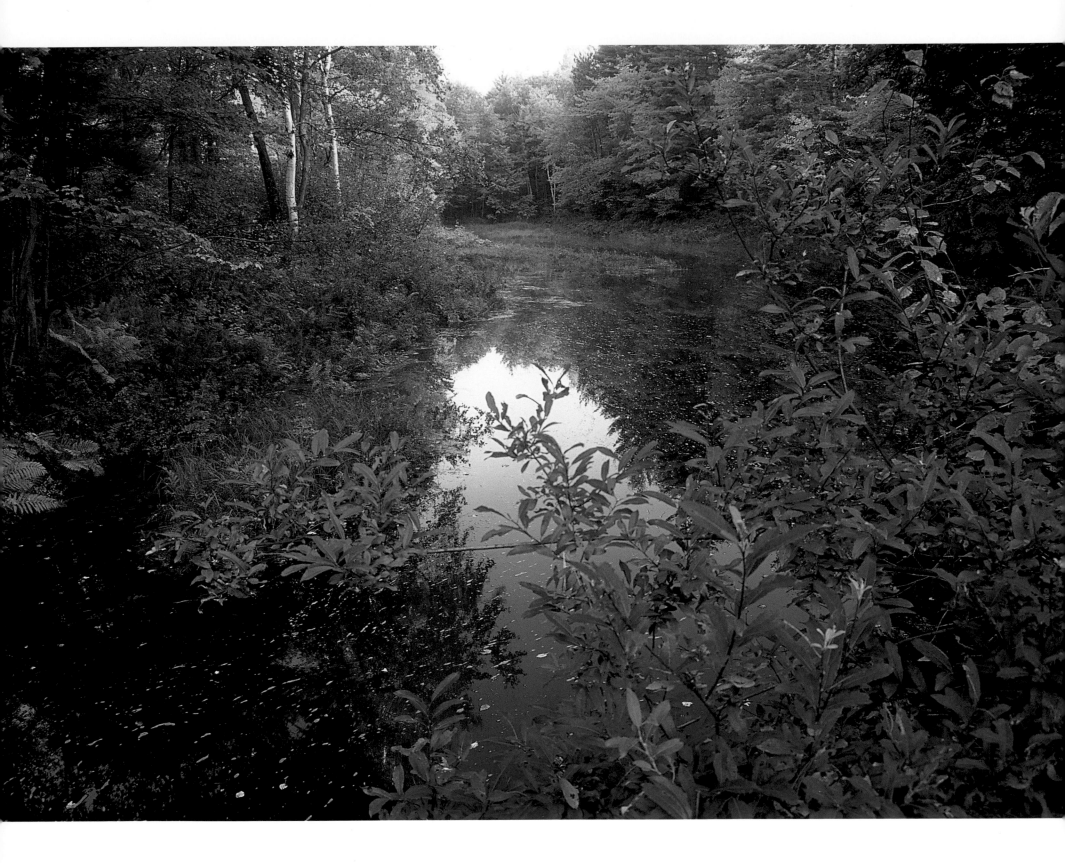

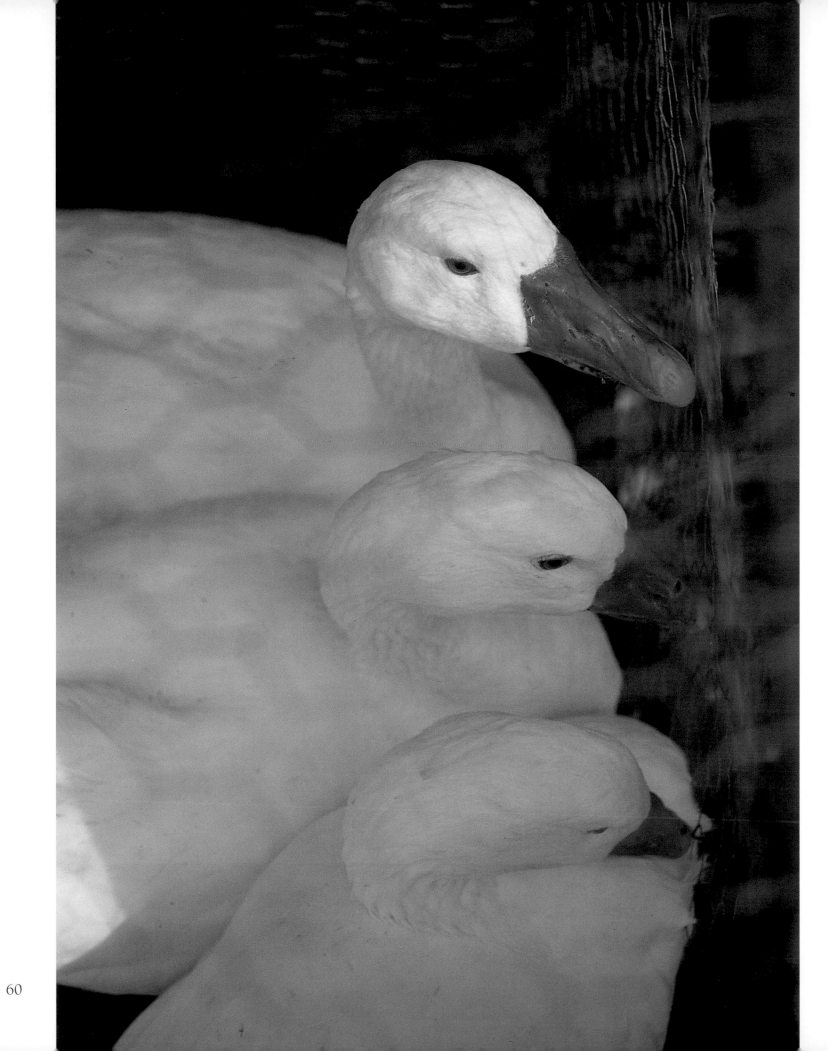

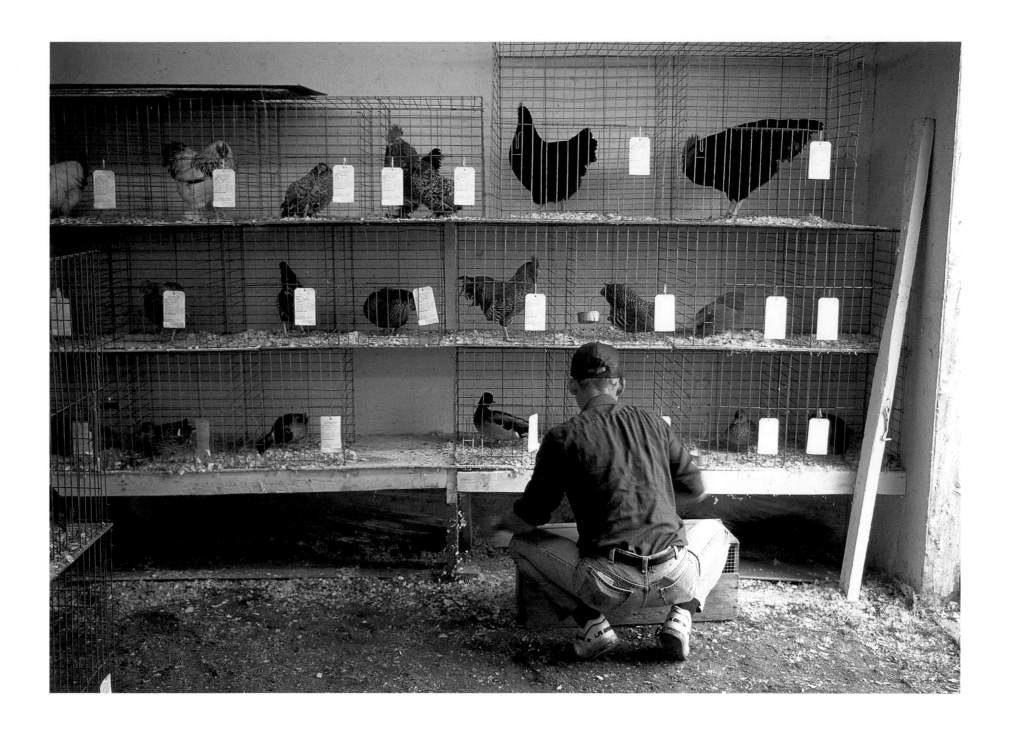

Hen checking at the Fall Fair, Huntsville.

OPPOSITE: *Competitors at the Huntsville Fall Fair.*

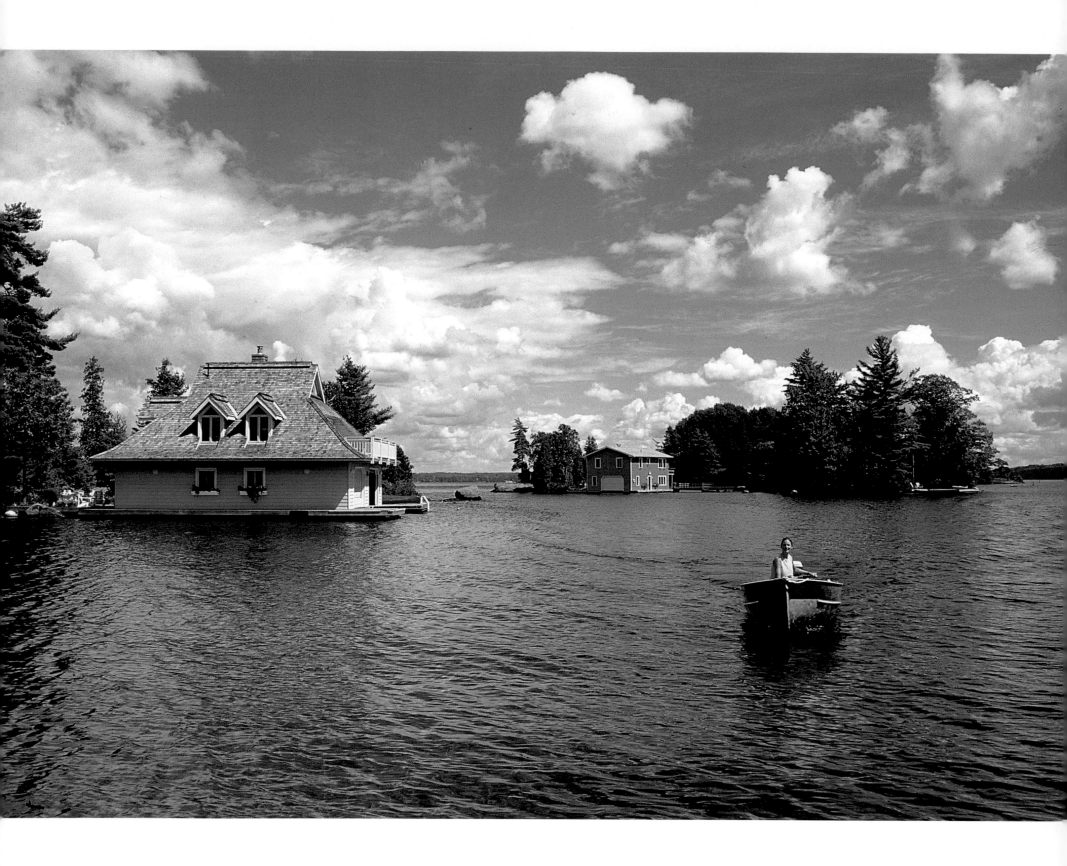

Mohawk Island at Rossclair, Lake Muskoka.

TINY ISLANDS

In the summer of 1995 a howling storm blew into cottage country, toppling trees and ripping off rooftops. We cowered on our tiny island that night with no power, exposed to battering winds on all sides, wishing we were anywhere else in the world. On small islands such as ours when a storm whips up there's no place to hide. At such times we curse our exposed little island.

But at other times, when westerly breezes blow softly and the lake is sprinkled with golden sequins, tiny islands seem like pieces of paradise. We relish our wraparound views. We can watch both the sunrise *and* the sunset and, on certain nights, we have a clear view of the moon casting its silvery path across the water.

On the map, islands like ours look like mere specks. But they are in fact pocket-sized estates with a little of everything — proof that good things come in small packages. A few trees; small patches of earth planted with herbs and daylilies; bare lichen-encrusted rock; and shoals just beneath the water surface, ideally placed as rest stops for an around-the-island swim.

"I know every dent in the shoreline," muses one woman whose island is no bigger than a hockey rink, "and I can tell if the water level is up or down by even a smidge. When it's low, my island seems far grander."

Another islander confesses, "We've become so familiar with our tiny property that we know every nook and cranny, every tree and shrub. And when we have to escape from each other, which does happen in small spaces, we all have our own special hiding places."

Escape from these confined spaces is sometimes the first instinct, often for restless guests, but almost always for large dogs who can get bored on small islands. One summer we left Tory, an elderly Irish setter, on our island by herself when we went to town. "She'll be fine," her family assured us, "she'll just curl up in a corner and go to sleep." Three hours later when we returned, Tory was not curled up and sleeping. She had swum across the channel and was sitting in our boat at the mainland dock crying like a baby.

Most tiny island cottages have been around for a while. That's because they couldn't be built today. The islands are too small. And so most were bought by an ancestor who built the cottage back in the pre-permit days. "My grandfather used to picnic on this island," claims one cottager. "He loved it so much he ended up buying it. We feel lucky because the cottage is built right on the water — something that couldn't be done today."

By now, my family has spent many decades on our tiny island. It's true we're more vulnerable to the whims of nature, more exposed to bursts of lightning and the lashing of waves. But on a calm evening when the setting sun lingers over the bay and the lake water around us has turned a pinky mauve, there's no place on earth we'd rather be.

The author on a summer afternoon.

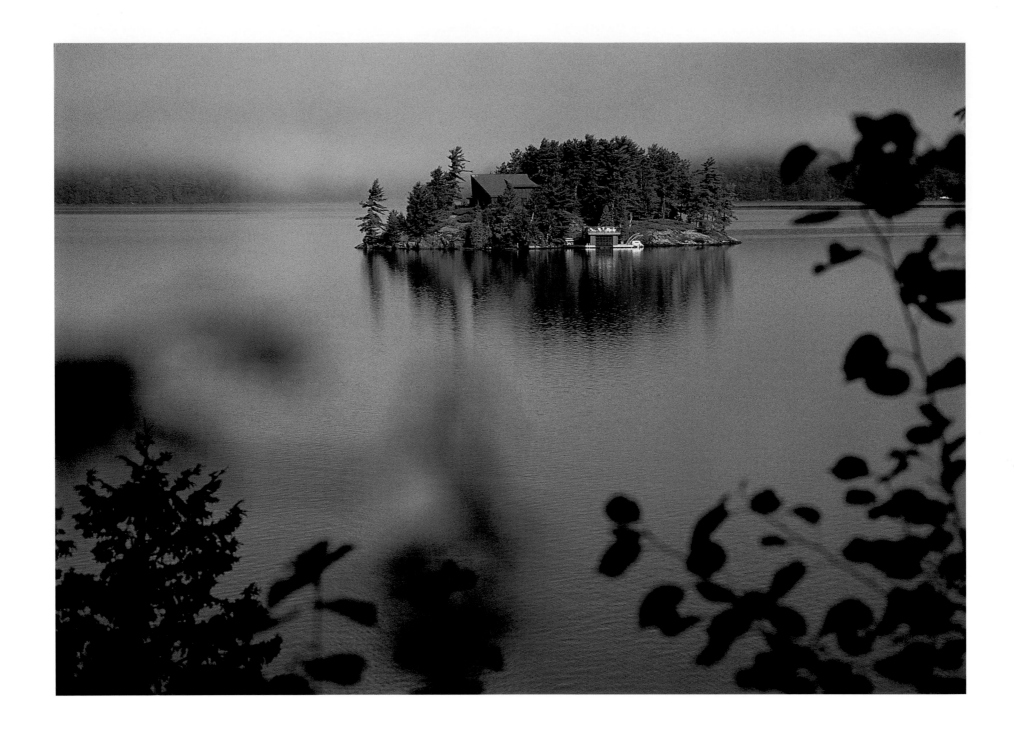

One island among many, this one in Mary Lake.

Opposite: *Lake Muskoka, a lake of many islands.*

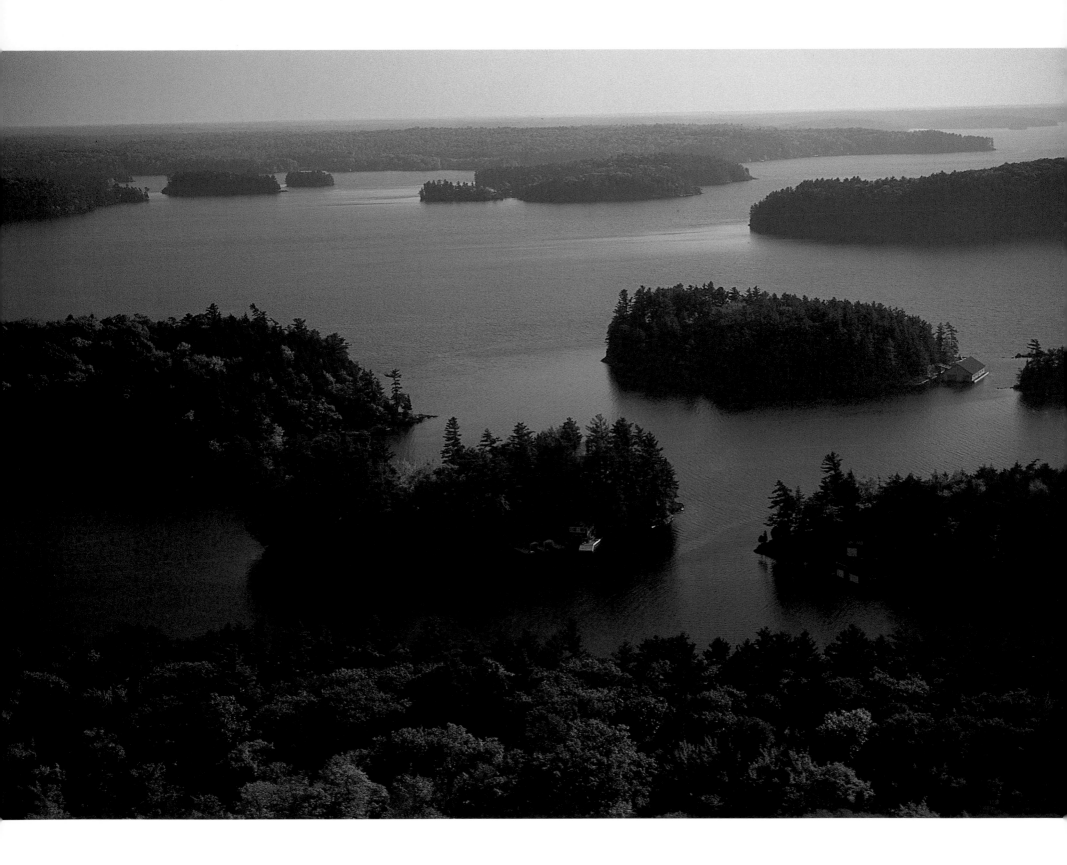

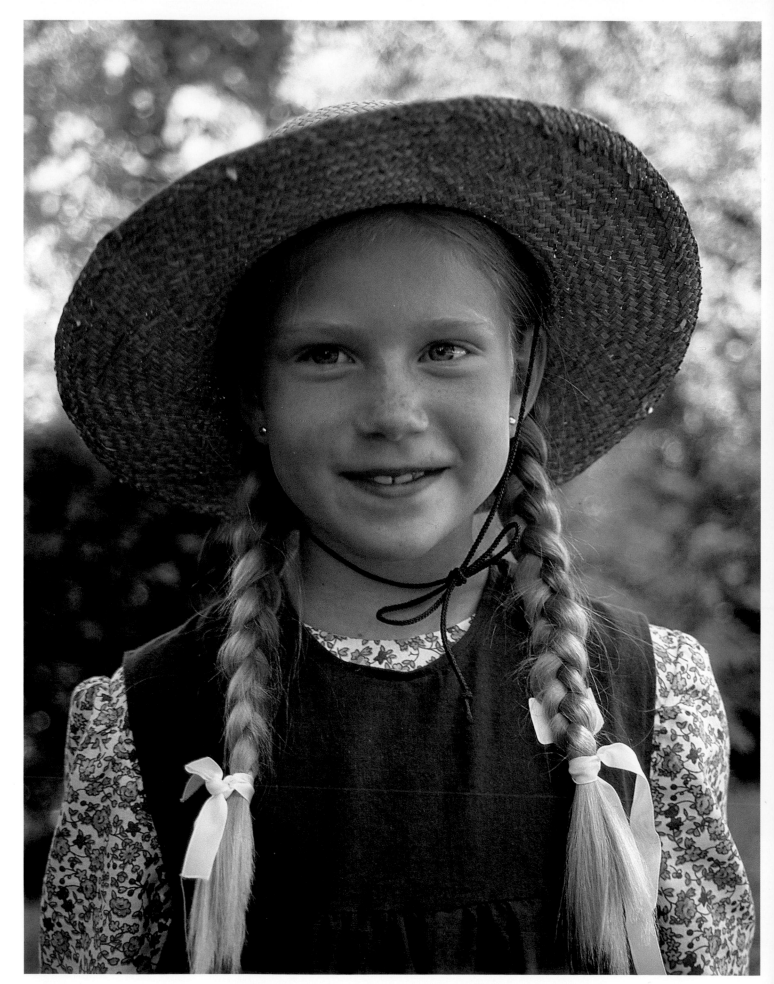

Emily Kichler, winner of the annual Anne of Green Gables lookalike contest.

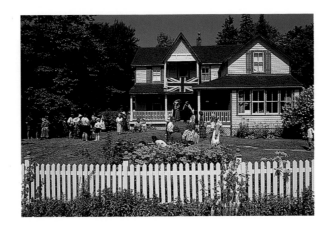

BALA MUSEUM

The gathering in front of the old clapboard house looks like a 1920s social tea party, except the people seem vaguely self-conscious in their vintage outfits. A faded Union Jack hangs from the upstairs balcony and five ladies in voluminous hats are singing sweet hymns on the verandah. On the lawn a handful of children in pinafores and knickers ignore the singers and skitter across the grass playing tag. Their mothers, clustered in the shade of a tall oak, sell lemonade for five cents a glass.

This scene is unfolding on a midsummer's day at the quirky little Bala Museum at the corner of River and Maple Streets. Linda Hutton, the museum owner, has been fussing with last-minute details, worried that nobody will show up for the ceremony. Every year since the museum opened in 1992 they have held this event, a reenactment of Lucy Maude Montgomery's arrival in Bala in 1922. "The local press ignored us this year," she says, "so I hope we get a crowd."

She needn't worry. By the time the Model T Ford pulls up to the garden gate with the costumed cast of characters, the lawn chairs have all been filled.

The story of this museum begins in 1990 when Jack and Linda Hutton went to Prince Edward Island for their honeymoon. Linda had always wanted to see the Anne of Green Gables home there, the literary birthplace of Anne Shirley, the well-loved heroine of a series of stories written by Lucy Maude Montgomery. While on the Island both Jack and Linda were intrigued to learn that the author had visited Bala in 1922 and stayed at Roselawn Lodge. It was by sheer chance when they returned home to Bala they discovered that the place where Montgomery had taken her meals, the tourist home across from Roselawn, was for sale.

"We bought the house a few months after we were married," says Jack, "and Linda came up with the idea for a museum." It just seemed natural to have an L. M. Montgomery museum here since the only book she wrote that didn't take place in Prince Edward Island was *The Blue Castle*, based on her visit to Bala. Montgomery had fallen in love with the little lakeside town, calling it "a dear spot." The idea for the book came to her in a daydream while she was staying at Roselawn Lodge. "Somehow I love it," she wrote of the town. "It has the flavour of home."

Today, the museum is a work of love for Jack and Linda, and Bala is becoming the Lucy Maude Montgomery capital of Muskoka. More than 20,000 visitors from twenty-four countries have already found their way to this unusual spot. Among the exhibits in the

Lucy Maude Montgomery Museum, Bala.

Rosseau Village store.

OPPOSITE: *Bannockburn Community Church.*

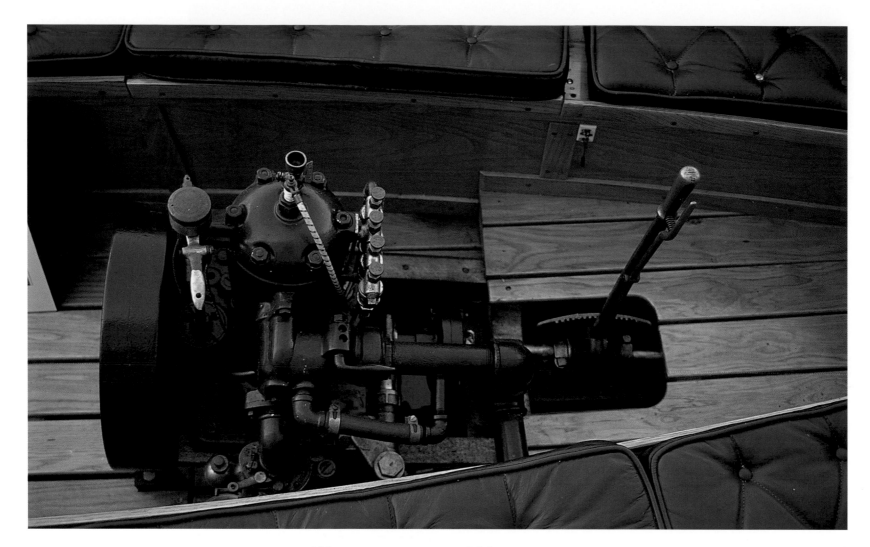

Old motors sometimes work like new.

Opposite: *Rowing scull at the Port Carling Boat Show.*

"I always loved the old place," says Paul, today sitting in his overstuffed living room surrounded by antique gramophones. "It was named Wharerah, meaning 'house of the rising sun,' because it faces east and the sun comes up directly across the lake. When my aunt owned it she accommodated as many as forty guests here during its heyday in the 1920s. She kept it going until the 1950s.

"When I read her diaries I'm amazed at how she managed," continues Paul. "She never drove a car. In winter she got around on snowshoes and in summer her only means of transportation was her disappearing propeller boat — also named the *Wharerah.*"

Today the *Wharerah,* now over seventy years old, still cruises about the lakes with Paul at the helm. He first drove it when he was just eleven years old. His dippy is one of about three hundred that remain of the 3,100 built in Port Carling between 1916 and 1924. Paul claims about a hundred of those are still in Muskoka. "Twenty-five of them are right in this area and I keep most of them going. Sometimes I feel like I'm running an orphanage," he says, "and they are my cantankerous brood."

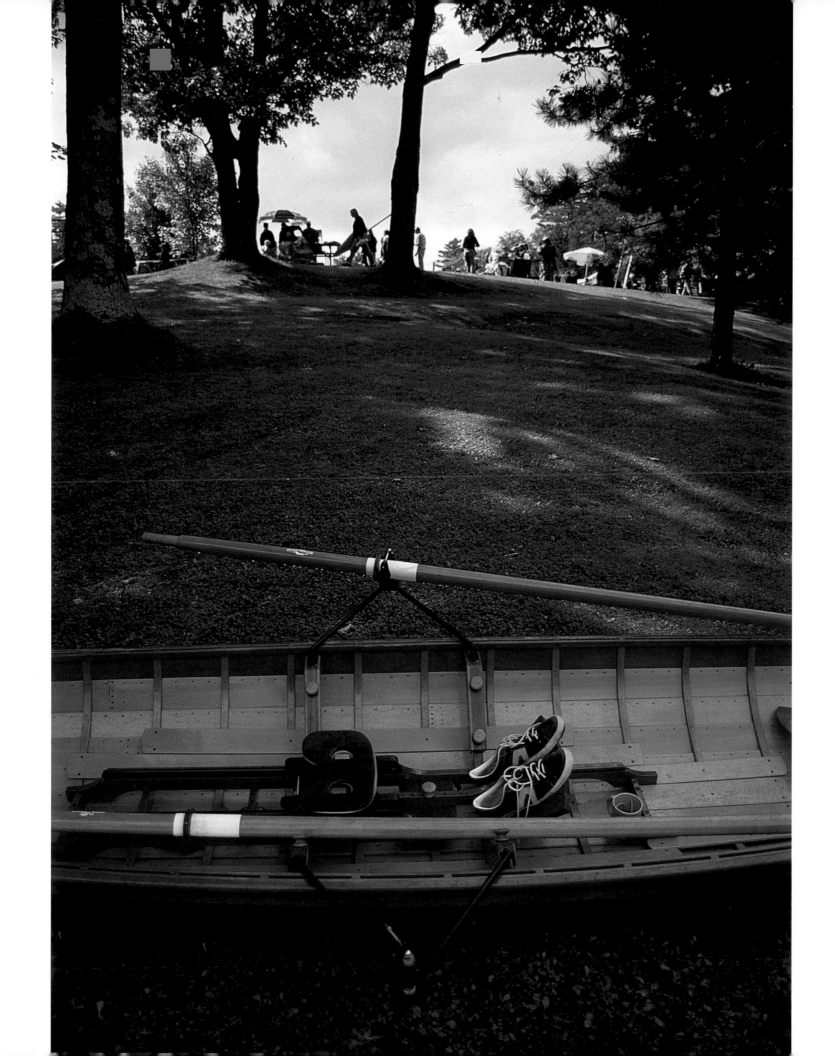

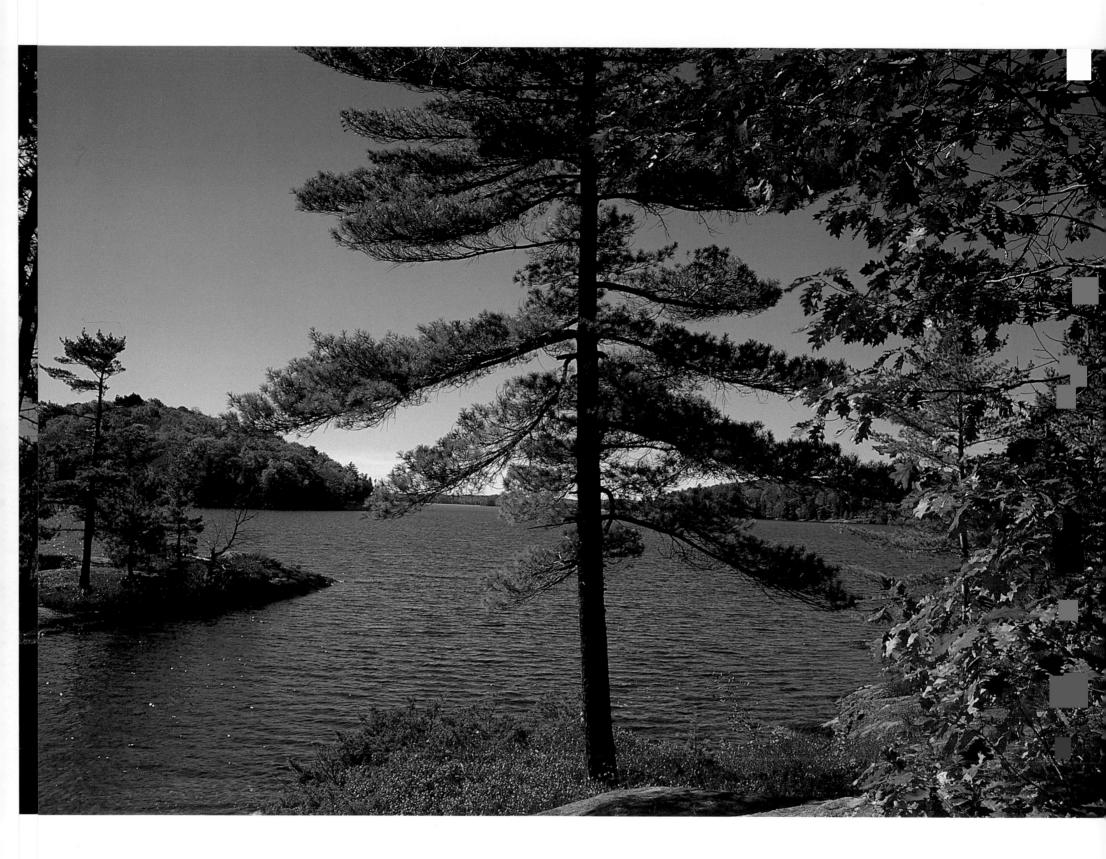

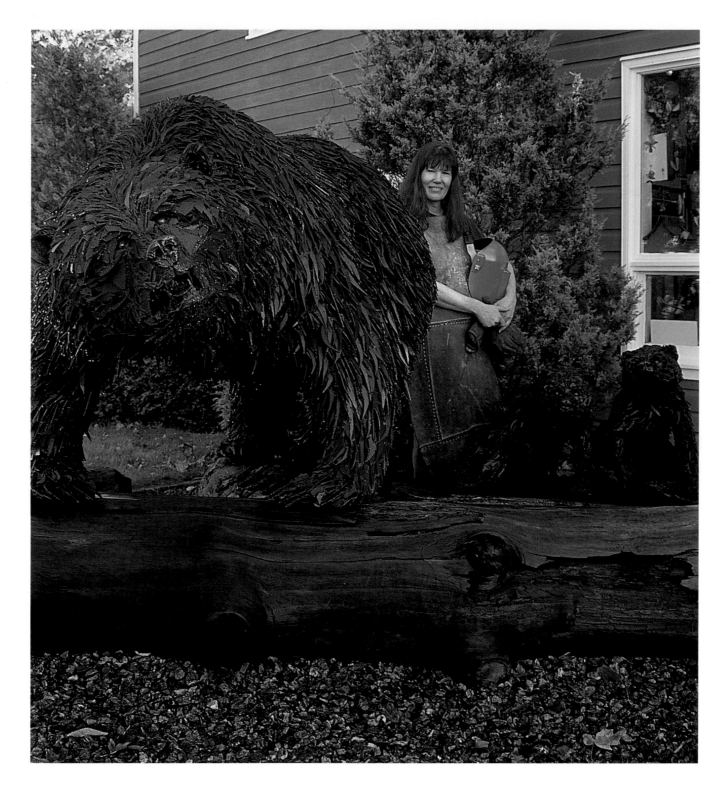

Sculptor Hilary Cole with her bears at the Tamarack Gallery, Gravenhurst.

OPPOSITE: *Lake Rosseau near Windermere.*

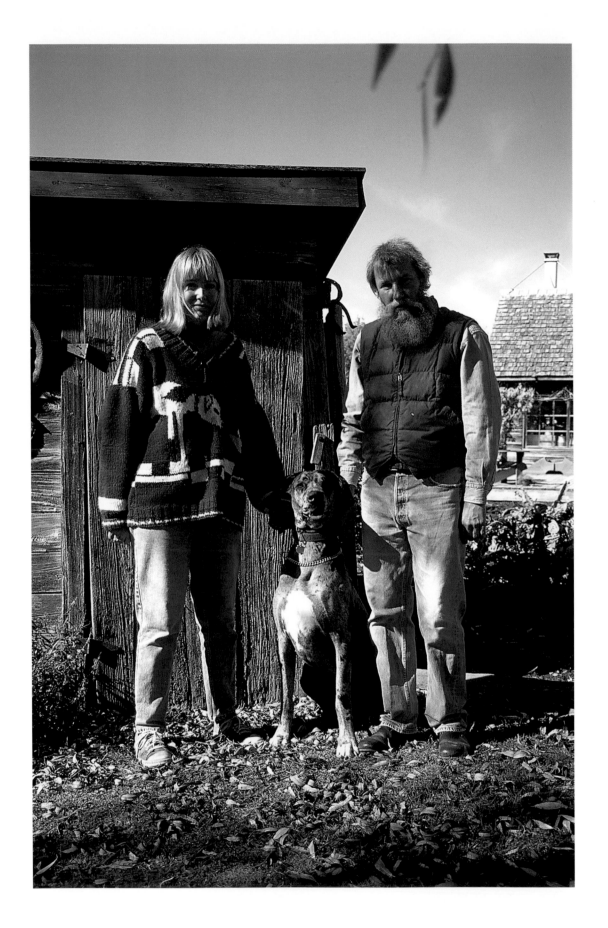

Suzann and Jon Partridge with Lucy
outside their pottery showroom.

OPPOSITE: *Huntsville from the Lions' Lookout.*

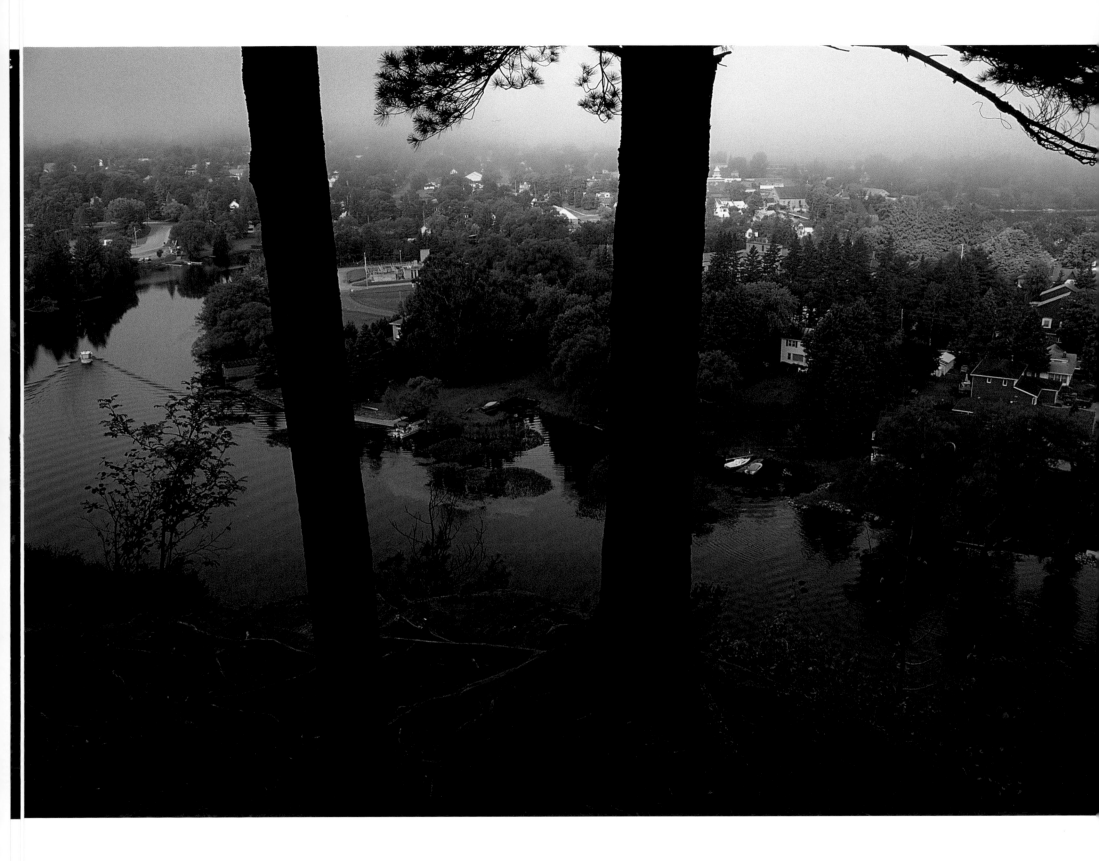

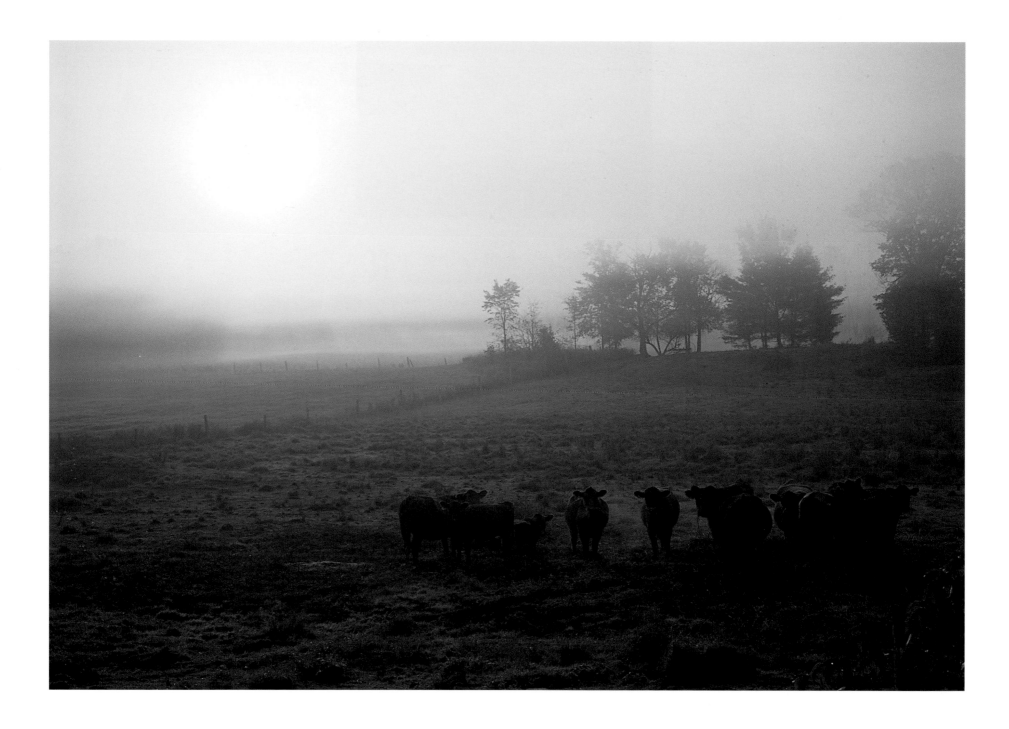

One of his secrets is early picking. Walker is convinced that the corn is better if picked when still cool at dawn. Once the sun warms the husks, the sugar content starts to break down. A successful corn harvest is just part of Walker Riley's commitment to this farm. His retirement goal, he claims, is to "demonstrate that there is a place in the sun for agriculture in Muskoka."

If he succeeds in this he'll be happy. But no matter what else happens at Brooklands Farm, the virtues of Riley's corn will always be remembered, as a wonderful late-summer treat and a topic of spirited conversation at dinner tables all over Muskoka.

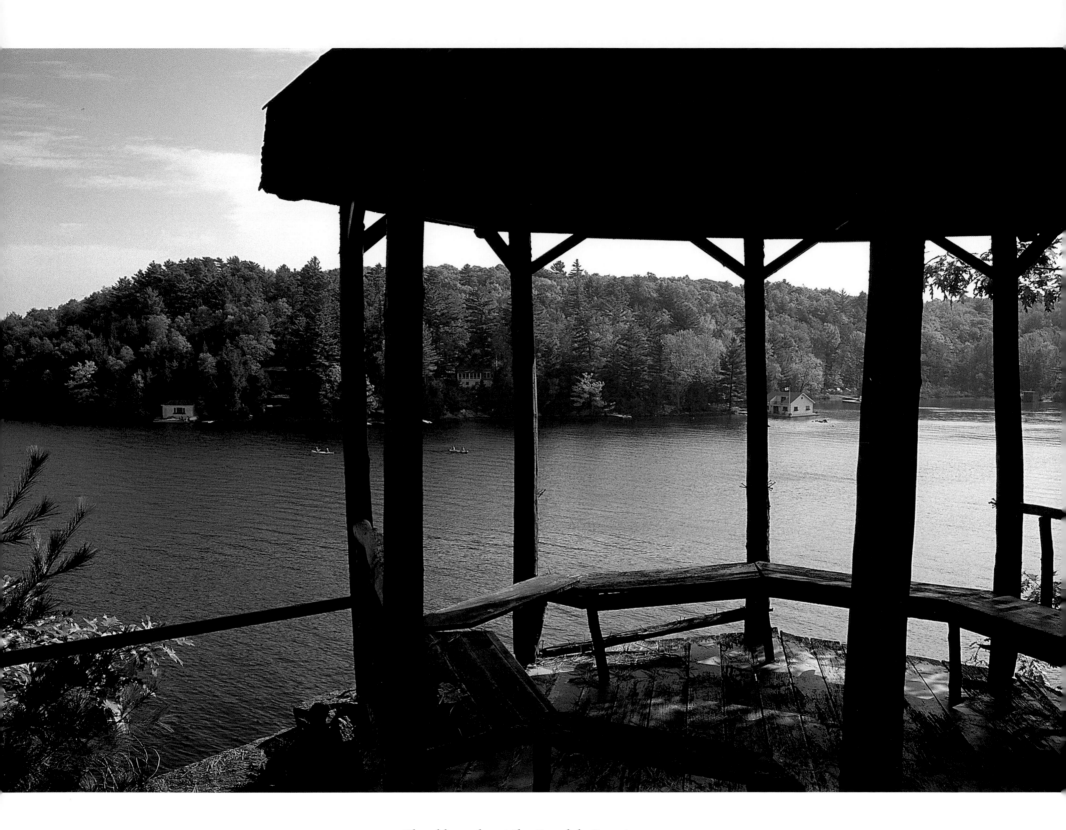

The old gazebo at the Ferndale Resort.

OPPOSITE: *A hazy morning near Sparrow Lake.*

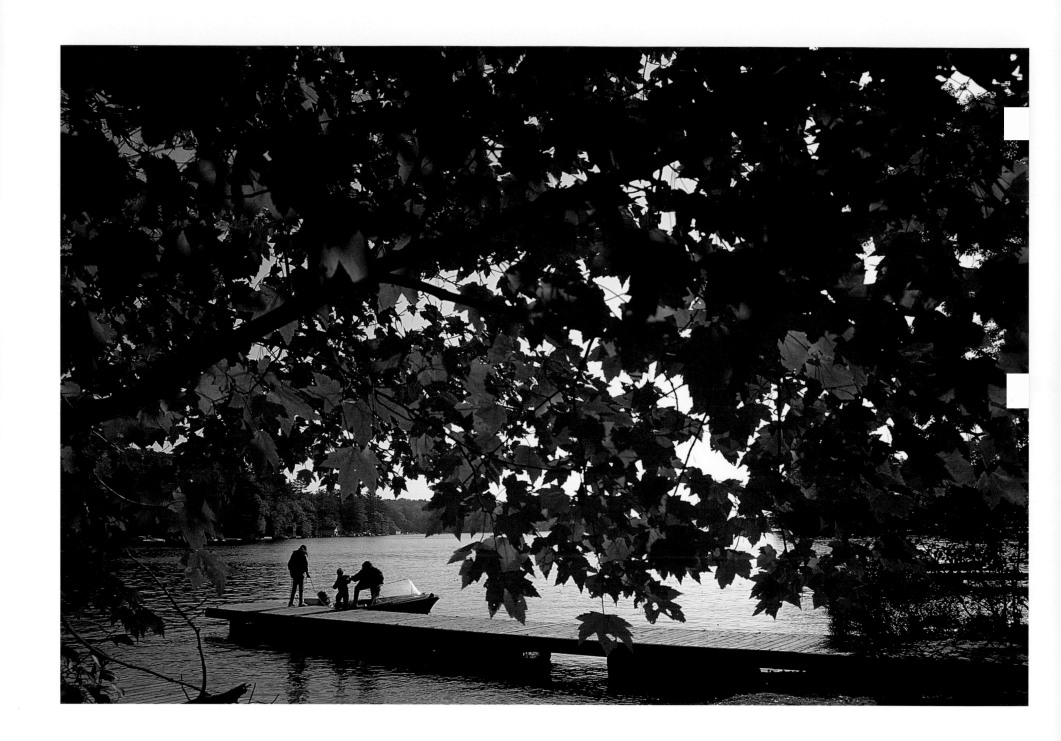

The maple leaf forever.

OPPOSITE: *A train curves through the woods near Bala.*

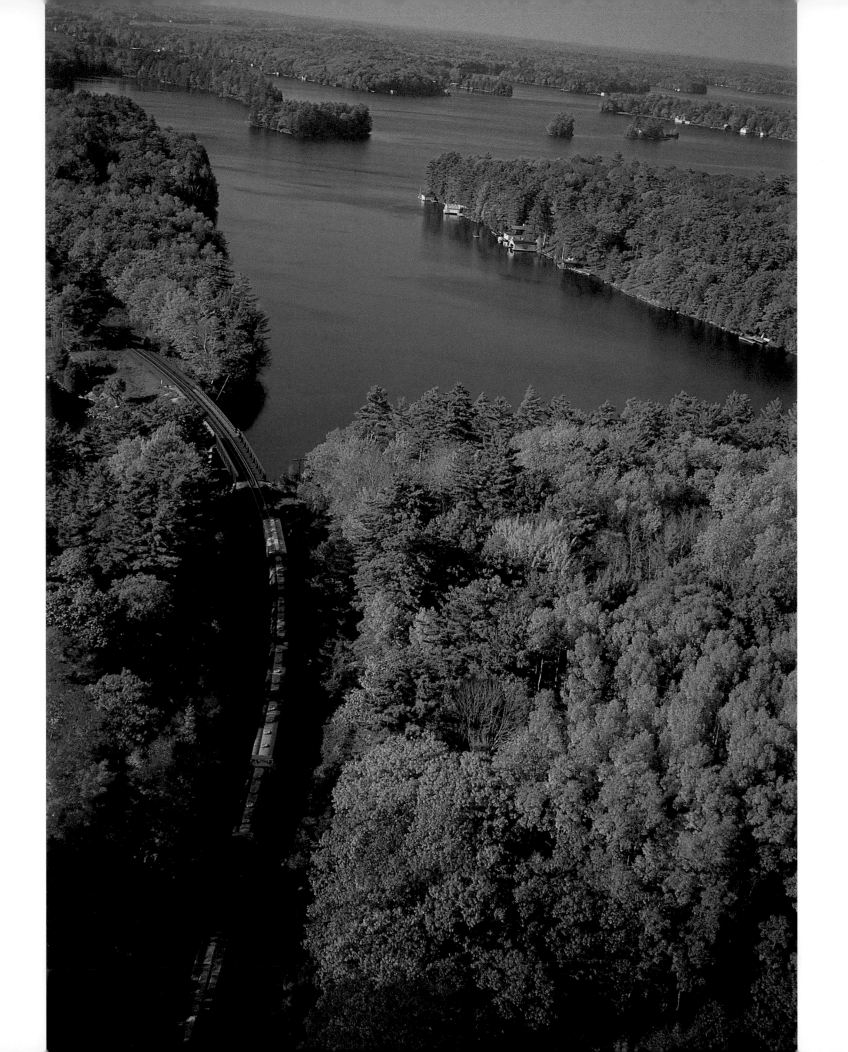

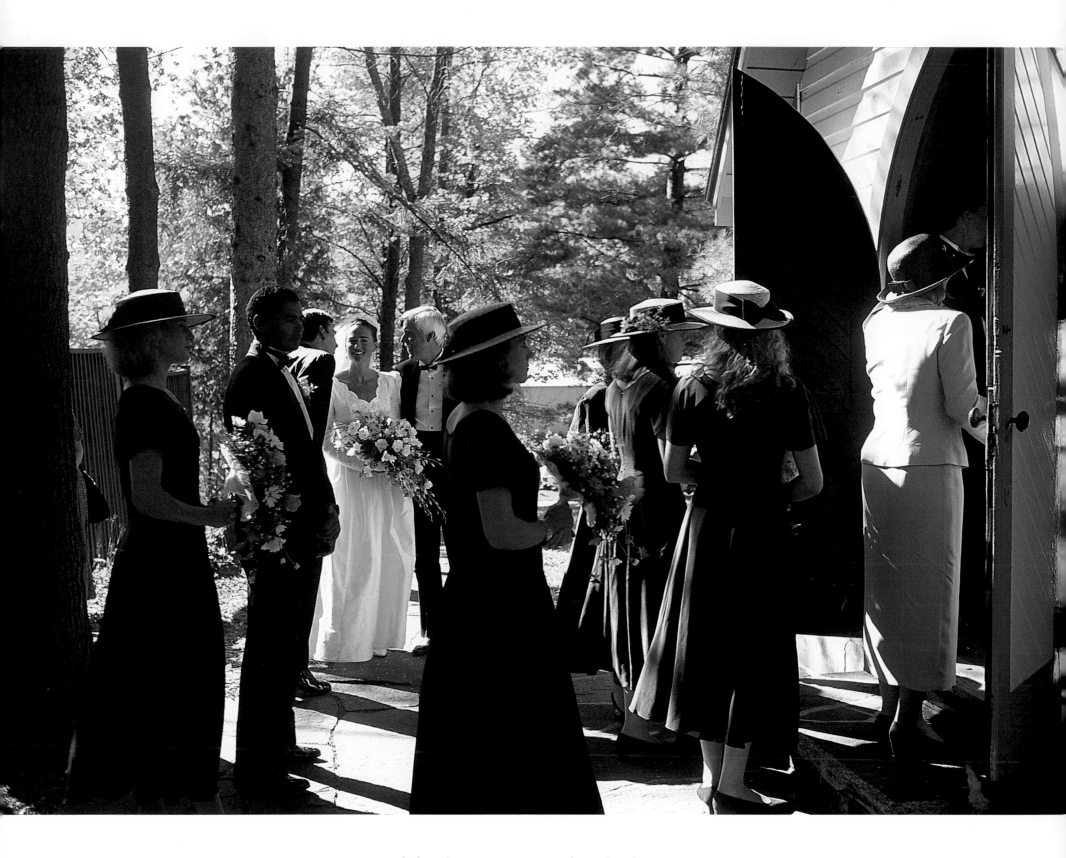

Just before the ceremony at St. John's Church, Beaumaris.

COTTAGE WEDDINGS

If there's any place in the world to which children become attached, it's the family cottage. No matter where in the world they settle, or how far they roam, they long to return to the cottage. "It's the only place I get homesick for," they'll say, endearing themselves for at least the first few days of their return visit.

And so, in time, when they decide to marry they dream of the "perfect" cottage wedding. These dreams — a bit like sugar plum visions — propel them to impossible ideals. Dancing in their heads are golden childhood memories of sun-splashed days and starry nights. They dream of a wedding where music wafts across the lake and the bride floats across the scene like something in a Chagall painting. In these dreams it never rains.

And so it was one summer at our cottage. Our oldest daughter, who had already taken up residence in British Columbia, wanted a Muskoka wedding. And we, her parents, knowing how much the cottage means to her, agreed to the idea without blinking. And so began a year of planning.

"Just a simple country wedding" was the way she presented the concept. And we actually believed it. It wasn't till later, after she and her fiancé returned West to resume their daily lives, that we learned — there is no such thing as a simple wedding!

A cottage wedding, it seems, is even more complicated. Transportation is more of a challenge — especially for islanders; caterers and florists are harder to come by; and because most everyone comes from somewhere else, they all require a place to sleep. Boats are notoriously unreliable — especially when depended on for "getting to the church on time." And septic systems are not always up to the demands of a large crowd at the cottage. Which is why our own island cottage was ruled out in favour of a mainland lodge.

"But everyone must *see* the lake!" our daughter insisted by phone during one of our costly long-distance calls. Her West Coast friends would be visiting Muskoka for the first time, so we caved in again and hired a boat, the *Lady Muskoka*, to take guests on a cocktail cruise following the ceremony. The simple wedding had begun to take on a life of its own. And then there was the question of weather.

Although our daughter truly believed it couldn't rain on her wedding day, her father was less convinced. He was glued to the weather reports all that summer. As rain fell steadily day after day, our concern at times mounted to panic. "If it rains we can always just cancel the boat trip," said my husband in his practical way. "Yes," said I, the more sentimental one, "but it's such an important

Through Gothic doors.

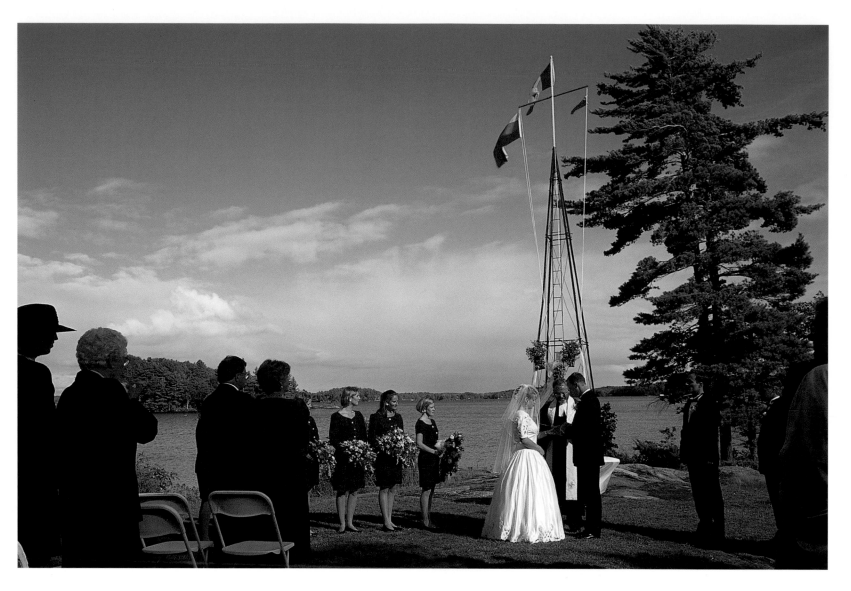

part of the day. So maybe if it's just a small storm with not too much wind . . . and we could have plenty of umbrellas. . . ."

The day dawned grey. It was September, the leaves had just begun to turn, and the warm lake was still wreathed in early-morning mist. By noon a light drizzle was falling. But the forecast, which we'd been up listening to since dawn, called for clearing in the afternoon. The wedding wasn't until three. There was still hope.

Just an hour before the event the clouds magically disappeared, leaving brilliant blue sky. The temperature was perfect, with just enough warmth in the sun to be comfortable outside. Luck seemed to be with us. "What a wonderful idea!" someone commented, "a Muskoka wedding on a perfect fall day." We nodded numbly as we headed down the country road to the tiny wooden church nestled beneath tall pines.

Looking back, it was wonderful. Despite moments of panic, sleepless nights worrying about the weather, and a host of logistical nightmares, we all have happy memories of that day. We remember the huge harvest moon that hung over the lake like an orange balloon as everyone danced outside. We remember the loving feelings. But mostly we remember our reason for having the wedding in Muskoka in the first place — because once the bride and groom have married at the cottage, it will forever be a place they come home to.

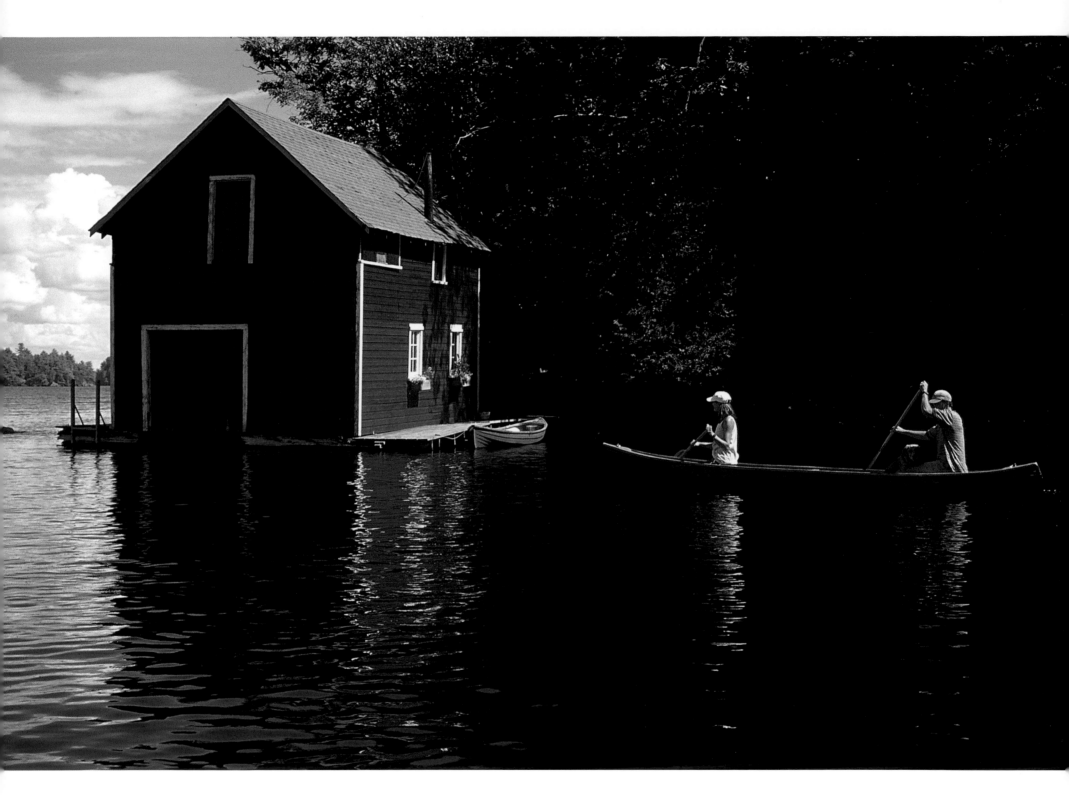

The bride and groom return to the cottage.

OPPOSITE: *Taking vows on the point, Lake Muskoka.*

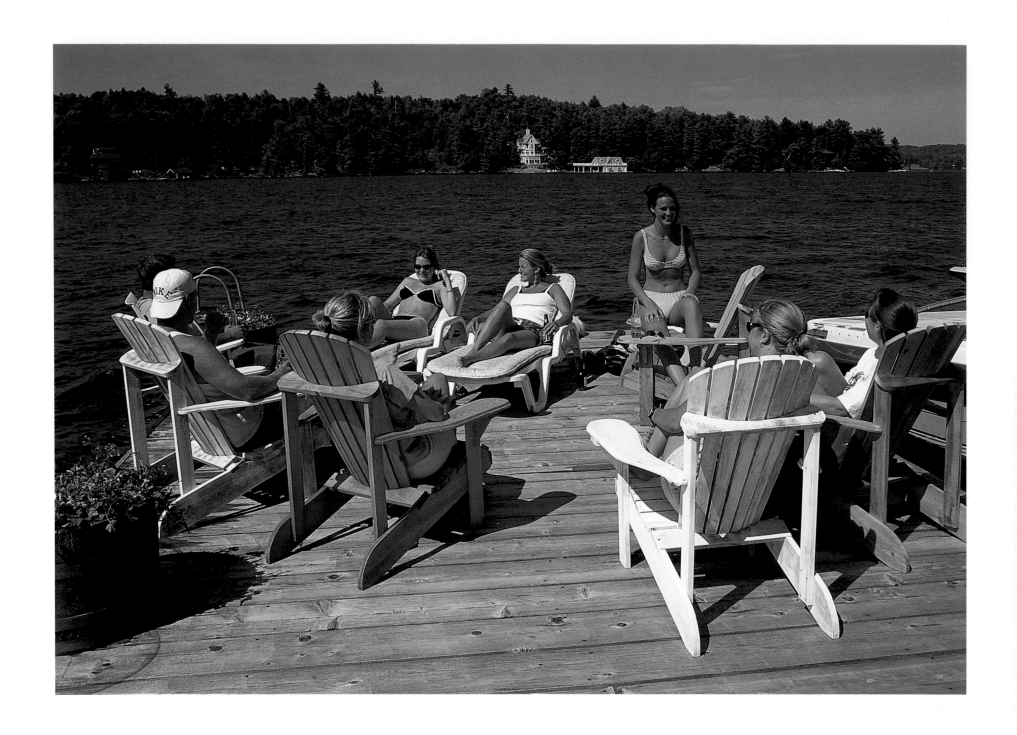

Lazing away a summer afternoon at Keewaydin Island, Lake Muskoka.

OPPOSITE: *Young fishermen from Wawanaissa Island.*

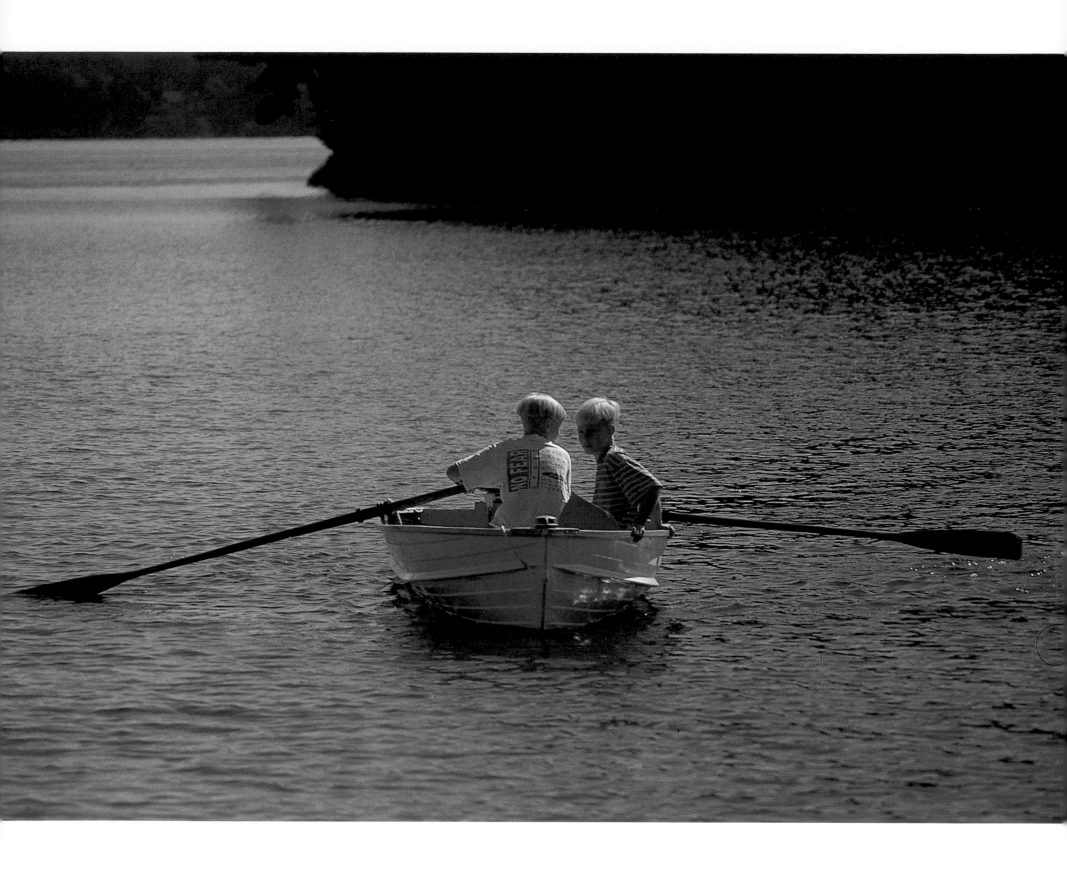

Don and Liz Mortimer, Mortimer's Point, Lake Muskoka.

OPPOSITE: *A log cottage on Lake of Bays*

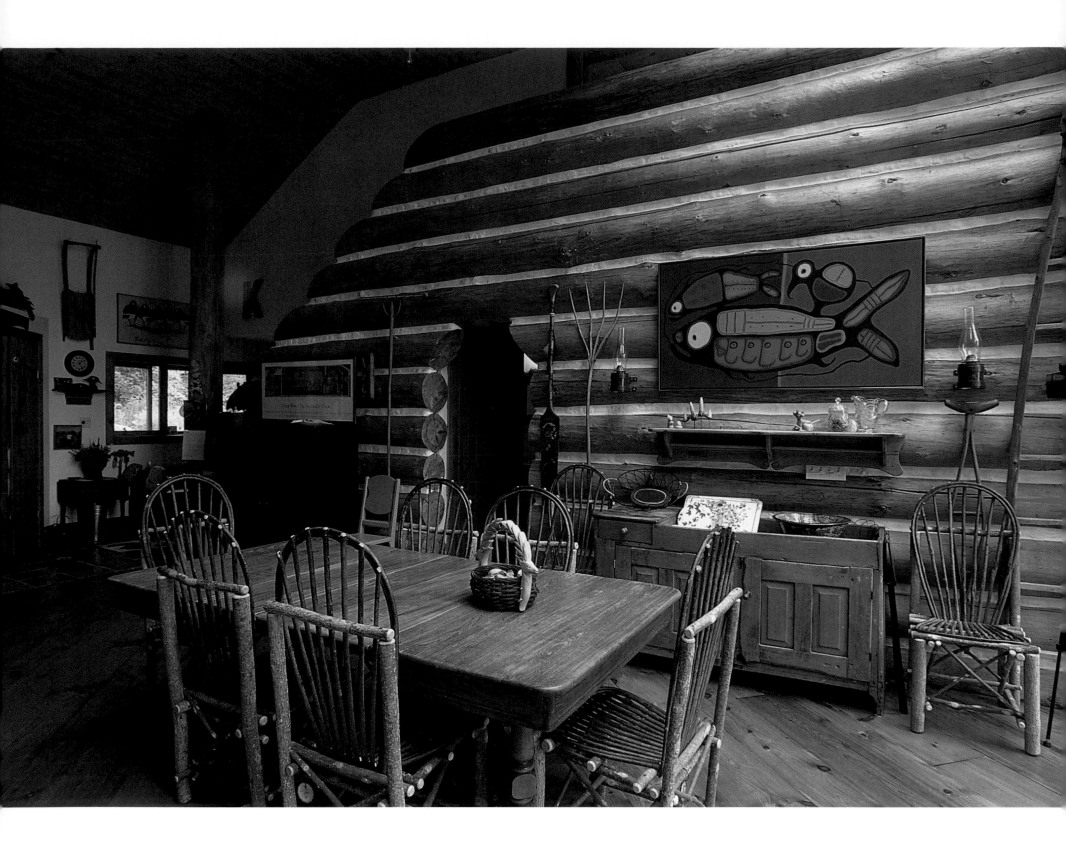

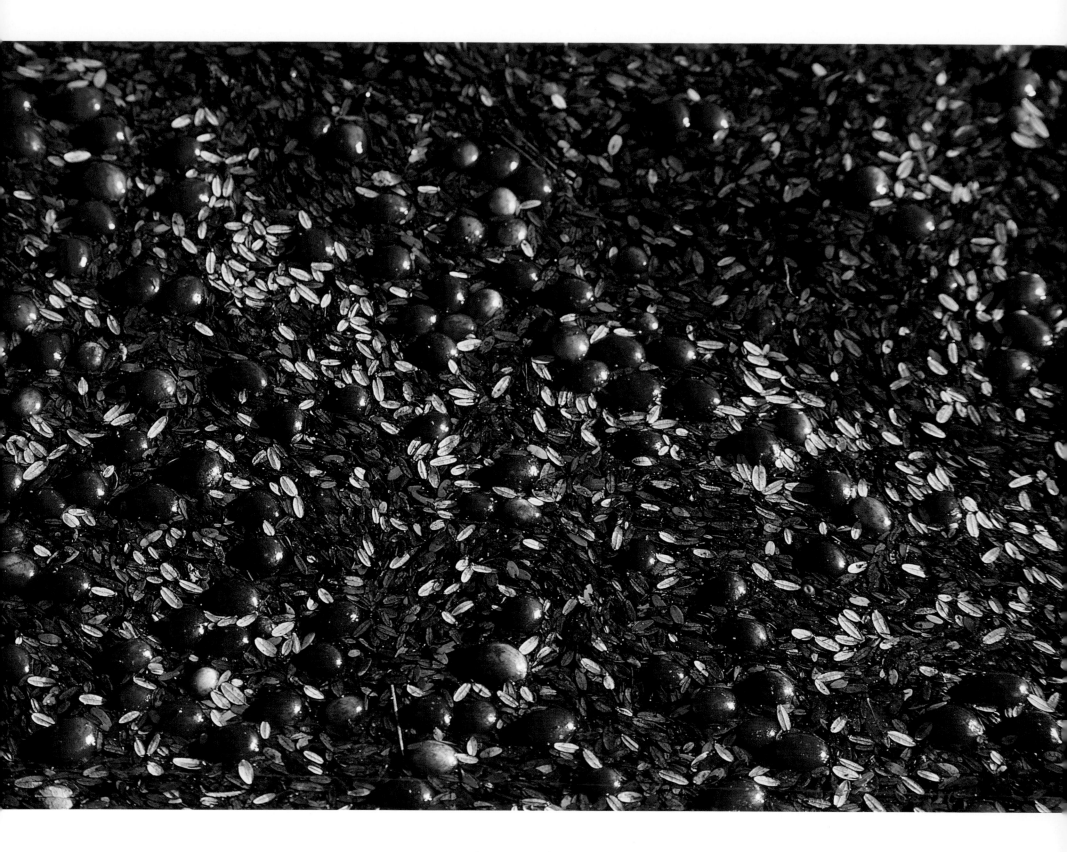

Cranberries at Johnston's Marsh.

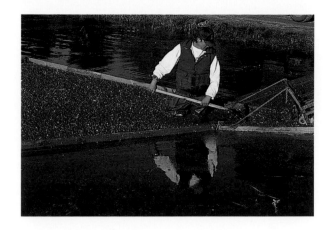

THE CRANBERRY HARVEST

The weekend after Thanksgiving was formerly a quiet time, with cottagers packed up and gone and the local people enjoying the countryside all to themselves. But no longer. For the past thirteen years the tiny town of Bala has welcomed cottagers and tourists back to Muskoka for the Cranberry Festival, an event that celebrates the harvest of this ruby-coloured fruit — and involves almost all of the town's five hundred residents.

Back in the early 1980s, one of the village councillors approached the Johnston cranberry-growing family about holding a special weekend festival in honour of the berry that grows so abundantly in the region's acidic peat bogs. Over one million pounds of these berries are harvested every year, making Bala the hub of Ontario's cranberry-growing industry. A perfect excuse for celebration.

If Bala is the cranberry capital, then June Johnston is surely the First Lady. In her role as matriarch of the family and home economics teacher, she has helped this tart crunchy little berry rise in stature to become far more than a saucy condiment for turkey dinner. Every year as the family business grew, she created new recipes, boiled and bottled more preserves. This year, in her own Gravenhurst kitchen, with a little help from some friends, she churned out over eight hundred dozen "Mrs. J's" cranberry preserves. After more than forty years of planting, flooding, harvesting, tending and preserving cranberries, she still laughs when she claims, "I always said I'd never marry a farmer."

But that was before June met her late husband, Orville Johnston, at McGill University in Montreal and he somehow sweet-talked her into moving to Bala to farm cranberries. He had already "got the bug," as she says, when he worked at a cranberry marsh as a young boy. He was also a musician, and part of the draw to Bala was Dunn's Pavilion, where famous big bands played. This meant Orville could earn extra income in the precarious early days of the cranberry-growing operation while at the same time the Johnston family was growing to include four children — two boys and two girls.

On this warm day in October over 20,000 people have come to the 13th Annual Cranberry Festival. The air is filled with the tangy scent of cranberry cider and the countryside is a blaze of colour. Red berries. Blue sky. Copper leaves. Pink and green candy floss in the food tent at the marsh. The activities, which spread throughout town, range from loon-calling contests to pony rides. But the most delightful of all is a visit to one of the cranberry marshes.

"Welcome to our cranberry farm," says Wendy Johnston, who is

Cranberry harvest at Wahta.

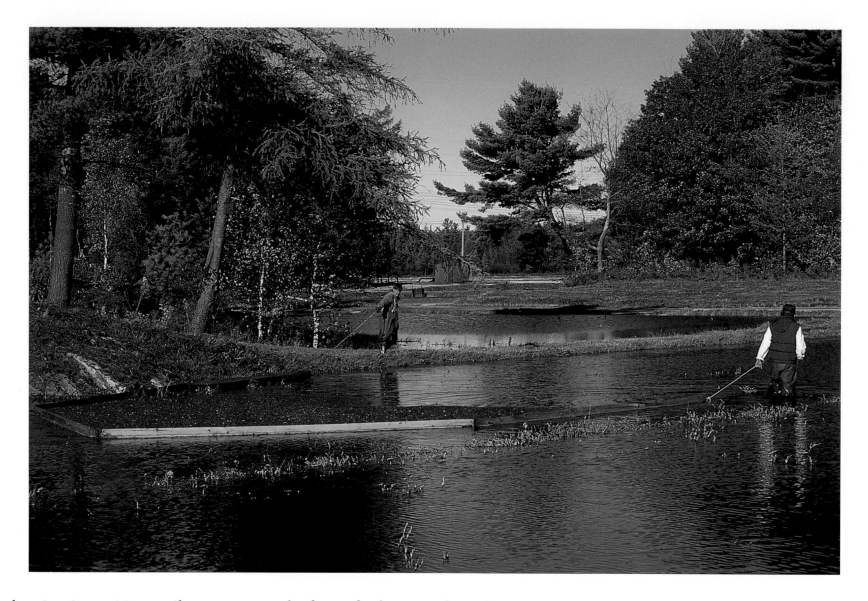

married to June's son Murray. She is sitting at the front of a hay wagon loaded with visitors — her six-month-old son, Rogan, bouncing along on her lap. "This little guy," she says, "is the third-generation cranberry grower in the Johnston family. I think his first words will be 'welcome to the farm.'"

The wagon rumbles alongside the cranberry bogs, which are flooded so the berries will float to the surface. Wendy explains the harvesting process, pointing out the mechanical picker that scoops up berries and gently combs them off the vines without bruising or damaging them. The berries are then collected in flat-bottomed boats before being emptied into trucks and taken to the packing house.

There they are graded according to their bounce — the better the berry the bigger the bounce.

For June Johnston, looking back on her years among the cranberries, her greatest joy is that her two sons are continuing the family business. Murray is running the Bala operation and Blake has recently bought a cranberry bog in Aylesford, Nova Scotia.

In the dedication to her Cranberry Cookbook, June says it all began with her late husband, Orv, "whose dream was to grow cranberries. He gave all of the family the drive to keep his dream alive and well." Soon it will be Rogan's turn.

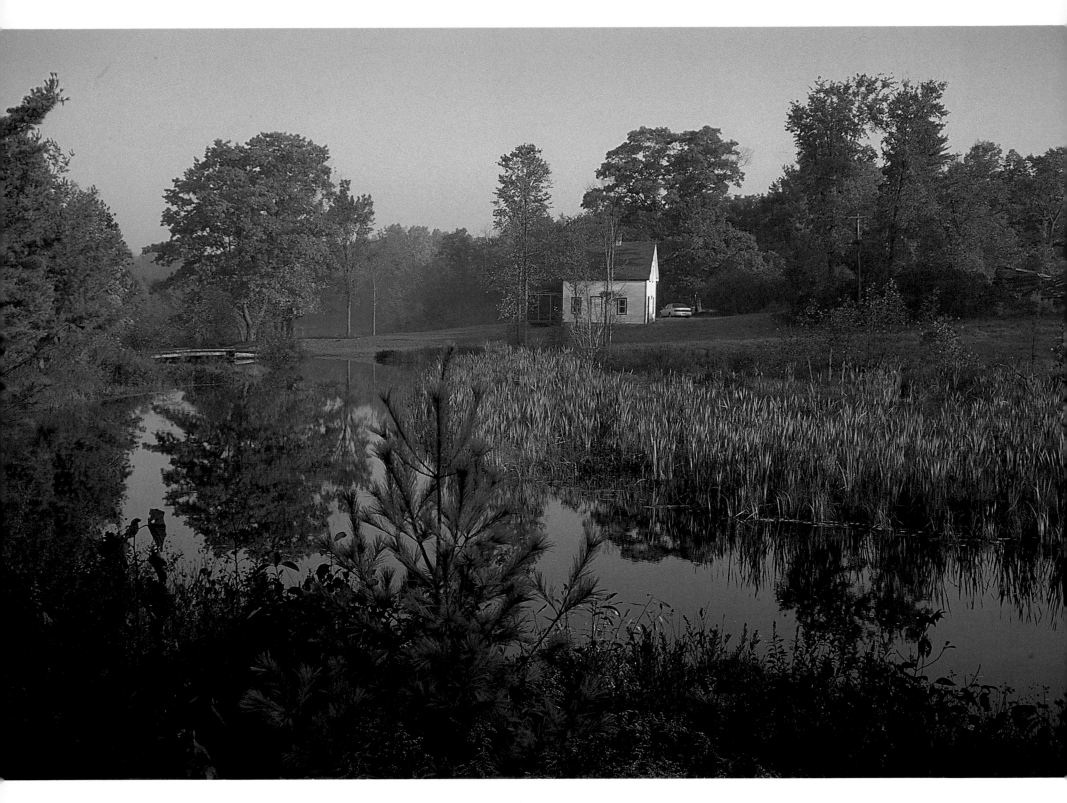

Southwood Road near Torrance.

OPPOSITE: *Cranberry harvest at Wahta.*

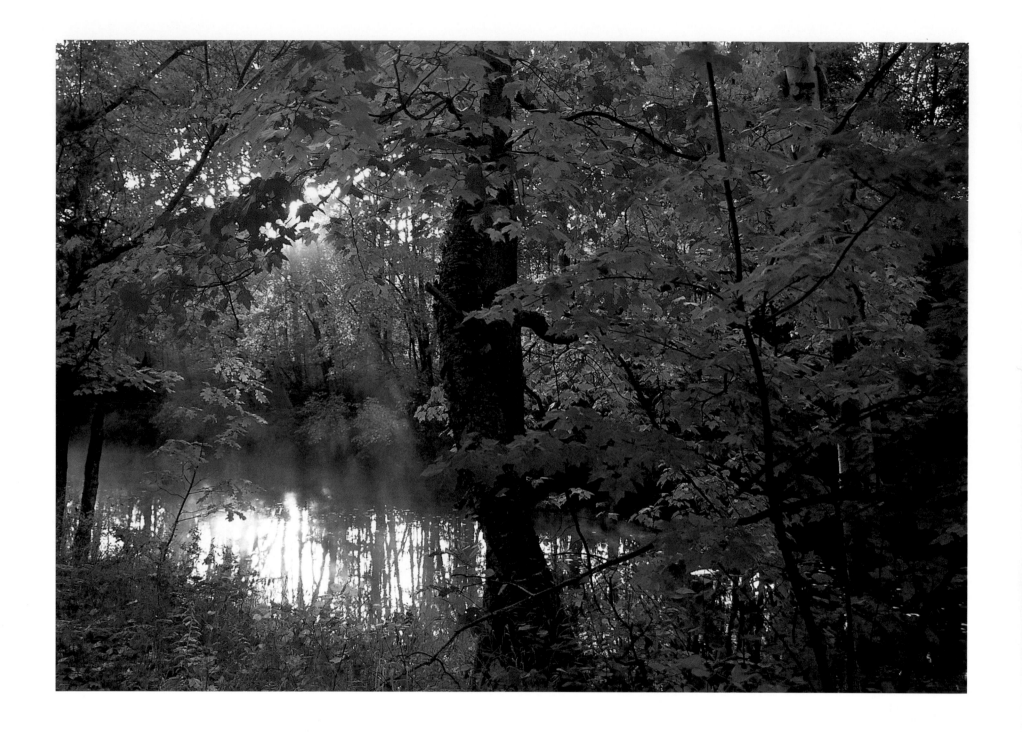

Reflections in the Black River.

OPPOSITE: *View from the Dorset Fire Tower.*

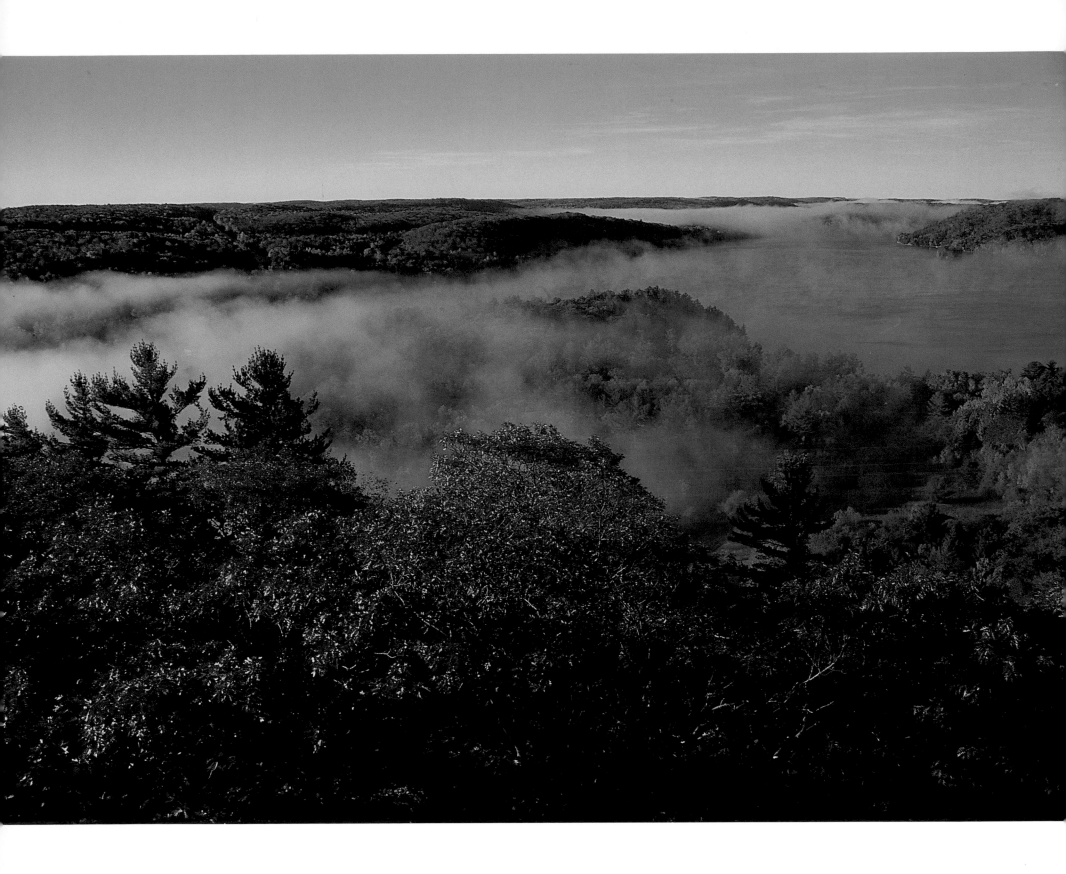

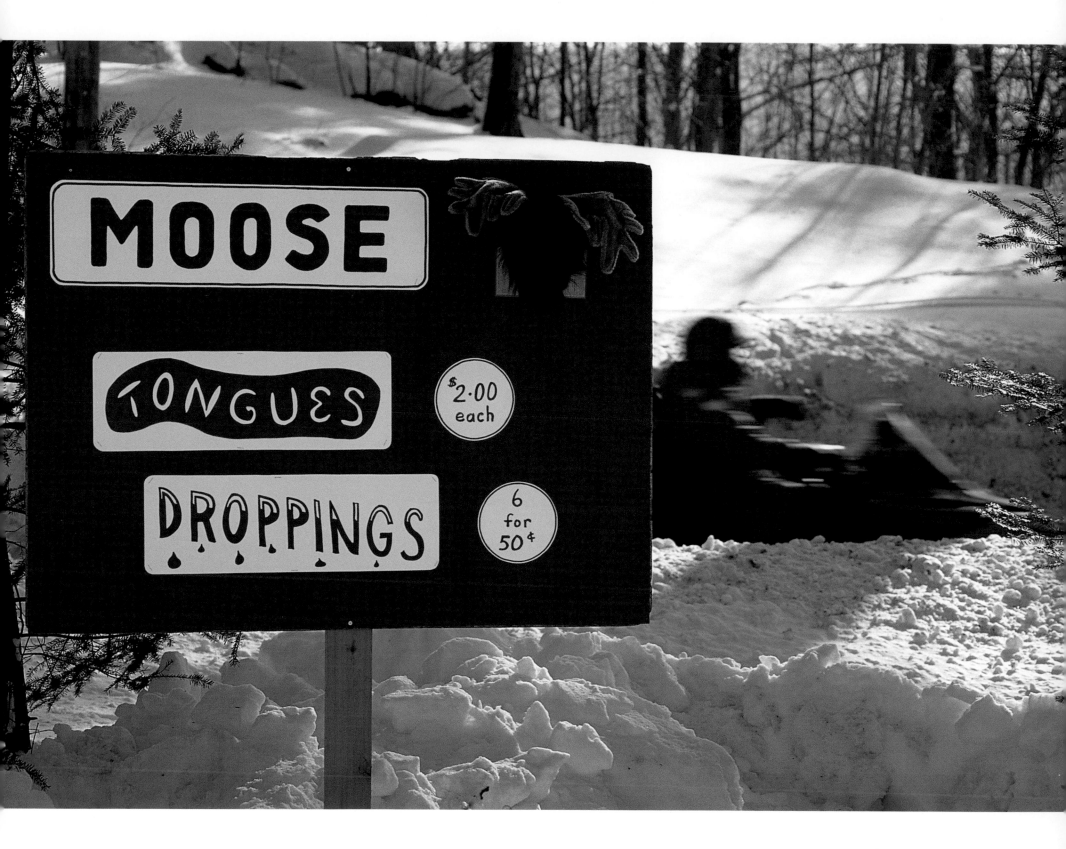

Winter Carnival, Dorset.

WINTER CARNIVAL

It's a cold, wind-whipped winter day, but Bracebridge is hopping with outdoor activity. A crowd gathered for the Polar Bear Dip is watching the shivering participants bounce about like boxers preparing to enter the ring. Every year in the middle of winter a group of brave — some might say crazy — souls dive into Lake Muskoka through a hole in the ice. So far every one of them has lived to tell the tale. This event, one of the most anticipated events at the thirty-year-old Bracebridge Winter Carnival, takes place in the park just beneath the falls, where a bathtub-sized hole has been carved from the solid lake surface.

First the polar bear dippers warm up in the temporary sauna built on the shore. Then, dressed in all manner of bizarre outfits, they race to the ice edge and leap into the frigid water. Some skid in with their feet first like pontoons on a seaplane. Others just hold their noses and jump. The crowd cheers.

All over Muskoka winter carnivals help to break up the long cold days, injecting cheer into the communities. The sillier the activity the better. In Huntsville they race beds down the main street of town; in Dwight there's a dogsled derby; in Baysville they crown a Snow Queen, and in Bracebridge, for those disinclined to polar bear dip, there's a donut-eating contest. But the zaniest of all events is in Port Sydney, where they really try to defy winter — holding a beach bonfire on the shore of Mary Lake. Complete with camp songs.

Increasingly popular in winter are snowmobile rallies. Fans of these speedy machines now have miles of trails newly carved out of the backwoods. Faceless beneath black helmets they roar along wooded trails sending up spumes of white spray, churning the snow into pie pastry.

Back in Bracebridge as the winter carnival festivities continue, the last of the polar bear dippers has scrambled out of the lake. The awards ceremony is about to begin. The dazed competitors are rewarded with prizes — for best costume; best water entry; oldest participant; and youngest, this year a nine-year-old boy. Thirty-one crazy fools took the plunge this year, and most of them say that, come next winter, they'll be back to do it again.

Waiting for faces.

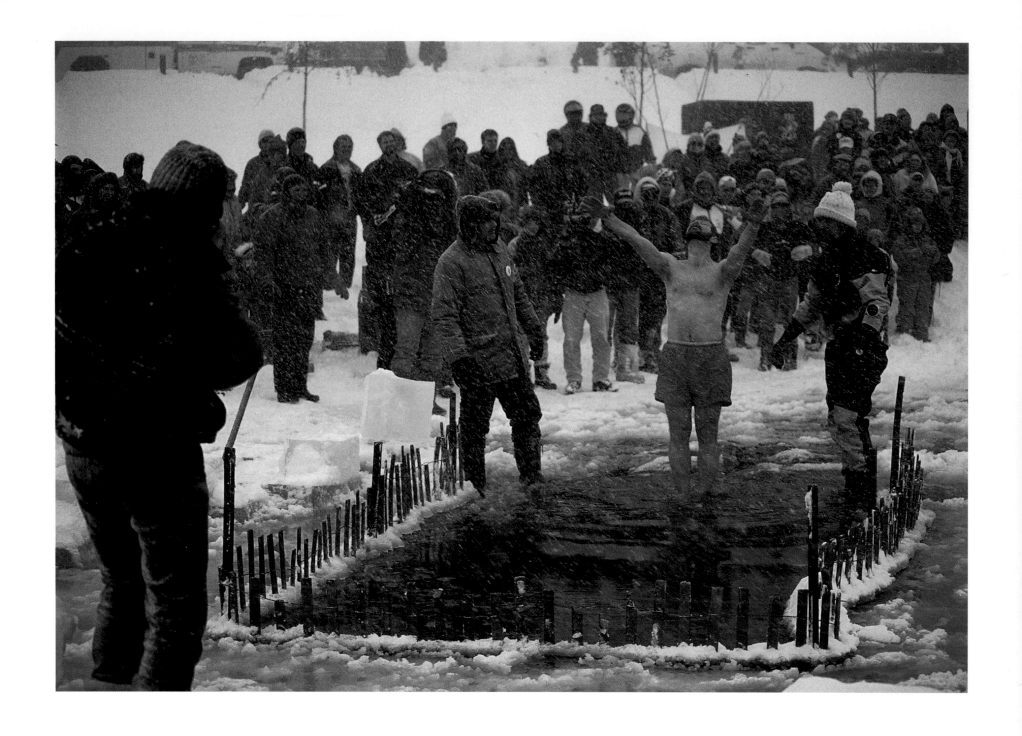

The Polar Bear Dip, Bracebridge Winter Carnival.

OPPOSITE: *The bright lights of Bracebridge.*

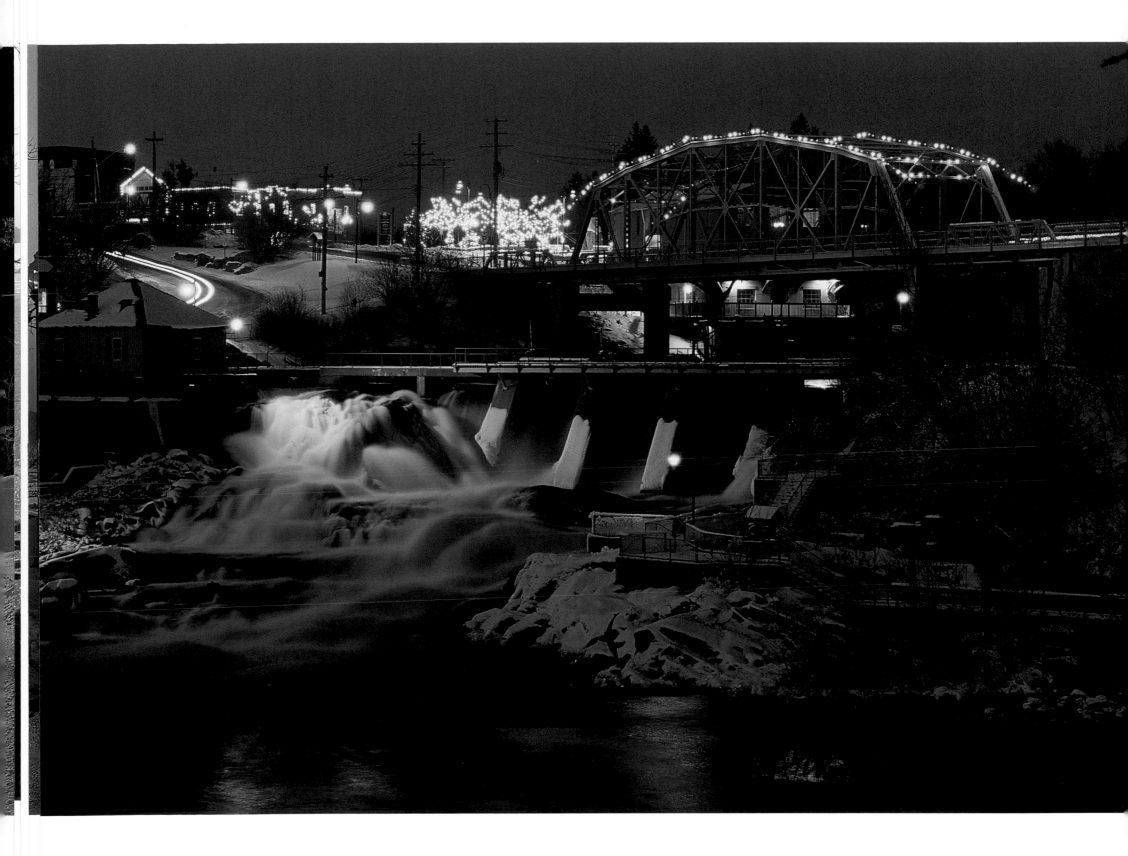

Along the Monck Road near Bracebridge.